STEAM AROUND BASINGSTOKE AND SALISBURY

Charlie Verrall

AMBERLEY

First published 2017

Amberley Publishing
The Hill, Stroud
Gloucestershire, GL5 4EP

www.amberley-books.com

British Library Cataloguing in Publication Data.
A catalogue record for this book is available from the British Library.

ISBN 978 1 4456 6392 0 (print)
ISBN 978 1 4456 6393 7 (ebook)

Typeset in 10.5pt on 13pt Sabon.
Typesetting and Origination by Amberley Publishing.
Printed in the UK.

CONTENTS

Introduction

With a grandfather who had been a footplate man on both the London, Brighton & South Coast Railway and Southern Railway, driving, among others, the LBSCR L Class 4-6-4 tanks; an uncle who was also on the footplate with both the Southern and BR, finally retiring from Selhurst depot as the divisional royal driver; and a father who was also a railwayman, it was not surprising that I became interested in railways at a very early age. In fact, my earliest memory is being taken by my mother to Horsted Keynes one lunchtime to see my father when he was a relief porter/shunter and then riding in the footplate of the shunting engine. This would have been before the outbreak of the Second World War. In addition I lived in a house at the foot of the embankment at Wivelsfield station, an area where many railway workers and their families lived.

In the summer of 1948 I started going to school in Hove, which meant a daily journey by train via Brighton. This was a good time to be travelling every day; the last of the light Bulleid Pacifics were being built, plus the sole Leader Class

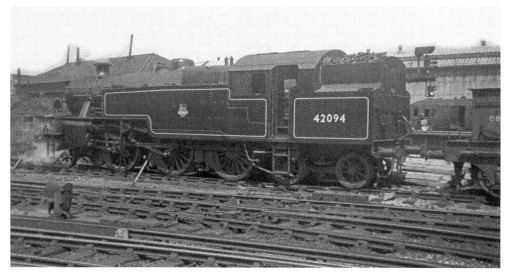

Fairburn Class 4 2-6-4 tank No. 42096 at Brighton, 21 July 1951.

locomotive, and finally Fairburn Class 4s and most of the Standard Class 4 2-6-4 tanks. The stay of the Fairburn tank locomotives on the Brighton area lines was relatively short, as they were not permitted through the narrow tunnels between Tonbridge and Tunbridge Wells, and eventually they moved away to be replaced by the Standard Class 4 tanks on those duties. However the introduction of these two designs hastened the withdrawal of the remaining LBSCR tank locomotives in classes E5 and I3, and the two attractive Marsh 4-6-2 J tanks.

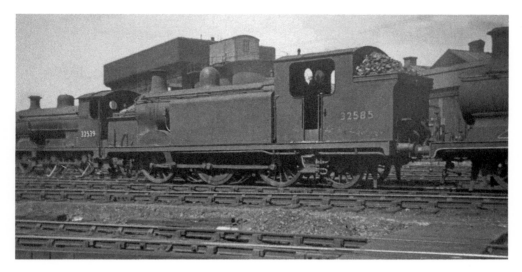

LBSCR E5 Class 0-6-2 tank No. 32585 at Brighton, 21 July 1951.

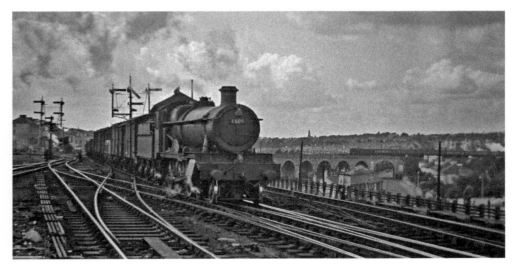

GWR Grange Class 4-6-0 No. 6809 *Burghclere Grange* entering Plymouth North Road on 8 September 1952 with a freight service.

Family holidays were in the West Country; one of our first trips was probably in 1950, going down on the Atlantic Coast Express hauled by No. 35005 and then going on to Exmouth. Later these family holidays were spent at Shaldon, on the other side of the River Teign to Teignmouth. Again we would travel to Exeter on the ACE, this time to Exeter St David's, and then catch a local service, invariably hauled by a GWR 5101 Class prairie tank. In retrospect I must wonder why my father chose to go via Waterloo rather than use the Brighton–Plymouth service, as our free passes would have been permitted on both services. Being on the Western Region visits were made to the stations at Exeter St David's, Newton Abbot and Plymouth North Road, where there were types of locomotive unseen by me in the London area – in particular, Grange Class 4-6-0s, 5101 Class 2-6-2 tanks and 6400 Class 0-6-0 pannier tanks.

Cricklewood shed, 2 May 1950. The locos are No. 43829, a Deeley Midland Railway 3F 0-6-0, and Johnson Midland Railway 2F 0-6-0 No. 58137.

The use of a box camera around this time introduced me to railway photography; my oldest negative is dated 1950. This was taken at Cricklewood on a visit with a spotters' club to which I belonged. I went on several visits with this group, coach trips on a Sunday to most of the London sheds, with the exceptions of the Southern sheds, Bow and Devons Road. There were so many highlights, with Stratford having most of the allocation present, plus the locos that were either waiting to go into Stratford Works or that were ex-works. One of the visits was in March or April 1950, when the remains of B1 Class 4-6-0 No. 61057 were outside Stratford Works, damaged beyond repair in an accident at Marks Tey on 7 March 1950. It was broken up during the following April. On another visit one of the J70 tram locomotives from the Wisbech & Upwell Tramway was present; these locomotives had the body enclosed with what looked like a guard's brake van body, side shields over the wheels, and motion and cowcatchers. King's Cross Top Shed was always full of Pacifics and suburban tanks, etc; in all, there were

S class 0-6-0 saddle tank No. 31685 at Bricklayers Arms, 2 July 1947. It was originally built as SECR C Class 0-6-0 685. (Mick Hymans collection)

several hundred steam locos to be seen each time, and even Neasden had several Great Central engines still there. Just imagine the prospect of seeing possibly over 1,000 steam locomotives, plus a few diesel shunters and the two ex-LMS main line diesels Nos 10000 and 10001! Sadly, other than the one taken at Cricklewood, no usable negatives resulted, as a box camera was not really suited for such busy locations. Although it was allocated to Camden shed, one locomotive always eluded me, even over my many visits to Euston as well – this was the unique Turbomotive No. 46202. Rebuilt as a conventional locomotive in 1952 and named *Princess Anne,* it was damaged beyond repair in the tragic accident at Harrow & Wealdstone on 8 October 1952.

Of course, there were other shed visits made, usually with a friend. One with a permit was to Bricklayers Arms in possibly April or May 1951. I know it to be around that date, as we saw the single S Class 0-6-0ST No. 31685. This loco worked much of its life at Bricklayers Arms until it was displaced by diesel shunters and transferred to Dover in May 1951. Its stay there was short, since it was withdrawn from service the following October. Another 1951 visit, although not with a permit, was to Reading GWR shed in November. On this occasion we saw one of the last two Bulldog Class 4-4-0s, No. 3453 *Seagull,* in a siding all by itself. Also on shed were several ROD Class 2-8-0s; these were Great Central Railway locomotives that had been built in the First World

LMS Beyer-Garrett 2-6-2+2-6-2, possibly No. 47981, at York shed in early 1950s. This could be one of those seen during my school visit to York. (C. Verrall collection)

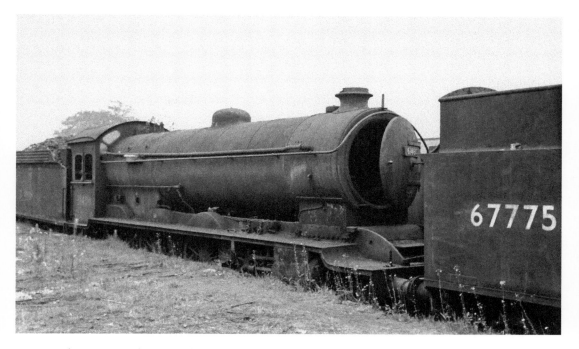

North Eastern Railway S3 Class 4-6-0 as BR class B16/1 No. 61460 at Darlington North Road scrapyard, 21 October 1962. This was a York engine and was possibly seen by me during my school visit to York. (Keith Long)

War for the Railway Operating Division of the Royal Engineers and were for all intents and purposes almost identical to the GCR locos that became LNER Class O4. A final trip worth mentioning was one with my school, most probably at Easter 1952. They arranged a mainly walking tour of part of North Yorkshire using youth hostels. The first port of call was York, where we must have arrived after nightfall, for it was not until we got up in the morning that we realised the hostel was on the other side of the river to Leeman Road engine shed, with loads of locos outside darkening the skyline. The memory of a line of LMS Garrett locos will always stay with me. The teacher in charge must have either been a loco buff, or really understood what schoolboys liked, for he had arranged for the group to not only visit York shed but also the carriage works and the then-small Railway Museum. Of course, we saw types that rarely ventured to the London area, such as B16 4-6-0s, D49 4-4-0s, J27 0-6-0s and J72 0-6-0Ts – a South of England locospotter's dream. What is unfortunate is that all my spotting records – not only during this period, but right up to when I stopped keeping logs of locomotives seen – have been lost. What interesting reading they would have made.

By June 1953 I had finished my schooling and had started work as a trainee booking clerk at Hassocks station on the Southern Region. My memory is that I was working on the day of the Coronation of Queen Elizabeth II – no days off

work for such an occasion in those days! After a short period I was transferred to Brighton Goods as a general clerk and the following year had moved to the district traffic superintendent's office at Redhill. Moves of this nature were the norm for young clerical employees with O-level grades. Moreover, it has to be remembered that all fit young men were expected to undertake a two-year period of National Service and so, other than the location, no full-time position was made available, although the employer was obliged to take back into employment anyone returning from National Service who wished to resume their career. While at Redhill I joined the Freight Timetables section, located in a wooden building adjacent to the running tracks with a splendid view of the train movements. One of the people I worked with was a railway photographer, and he suggested I get myself a better camera. However, the camera I eventually chose turned out to be not what I really needed. It had three shutter speeds, which was ideal. However it had a fixed focus and aperture lens, which, I was to find, made its use in railway photography difficult until I had mastered the selection of the most suitable film stock. At that time I was a raw novice photographer, never having had any training. During my early days at Redhill I had met up with another lad of the same age and we went on several spotting trips together. When he got his call-up papers, we wrote and applied for some

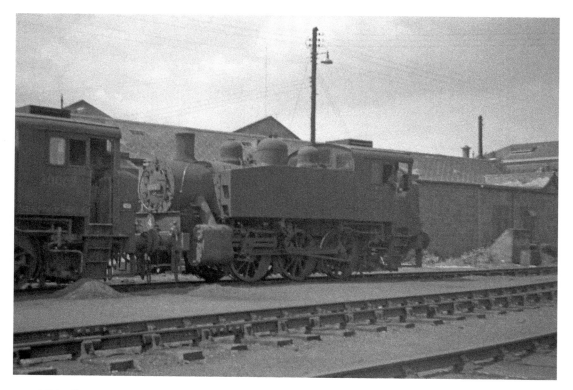

USA Class 0-6-0 tank No. 30067 at Southampton Docks, 8 July 1955.

shed permits and to our surprise got them without delay, resulting in a visit to Eastleigh sheds. On the same day we were permitted to visit Southampton Docks, where I was able to photograph a couple of the USA Class 0-6-0 tanks. However, I do not recall seeing any of the ex-LBSCR Stroudley E1 Class 0-6-0 tanks, and I think they tended to work at the New Docks. It must have been about this time I also applied for, and got, a non-electrified lines trackside permit for the whole of the Southern Region.

At the beginning of 1955 I had received my call-up papers and was to spend the next two years in the Royal Air Force, stationed mostly in Germany. While in Germany I only came home on leave once, in June 1956, when visits were made to Salisbury and Basingstoke. The reason why I chose those two locations has been lost in the mists of time; it is possible that they were suggested to me when I called in at the office at Redhill to collect my discounted rail ticket forms. At that time I had not previously visited either location other than when passing through on the way to Devon. Our train invariably stopped at Salisbury to change crews and possibly locomotives as well; depending on which side of the carriage I was in, locos could be seen on the Southern sheds, with the GWR sub-shed of Westbury having closed in 1950. We always passed through Basingstoke at speed, hoping upon hope of spotting something on shed – possibly a N15/X Remembrance Class 4-6-0. What I did not realise at the time was the importance of Salisbury and Basingstoke as railway centres. The N15/X Class locos were of particular interest to me since they were rebuilds as tender locomotives of the LBSCR L Class 4-6-4 tank locomotives driven by my grandfather. After the electrification of the lines from London to Brighton and Eastbourne, they were rebuilt at Eastleigh by R. E. L. Maunsell as Class N15/X. Why the N15/X class number was chosen could well be described as a bit of a mystery, since, other than the wheel arrangement, they had nothing in common with the Urie and Maunsell Class N15s, the King Arthurs. They were initially stationed at Nine Elms and from late 1941 until mid-1943 six of the seven were loaned to the GWR to cover a shortage of motive power. The arrival of the West Country Class Pacifics at Nine Elms meant that the N15/Xs were not required at Nine Elms, and they were all transferred to Basingstoke, where they remained, being progressively withdrawn from service in the late 1950s. During the early 1950s several were sent to Brighton Works rather than Eastleigh for minor attention, as in the case of No. 32327 *Trevithick* – a bit like taking coals to Newcastle since to get to Brighton they would have had to pass Eastleigh Works; several also made their final journey back home to Brighton for breaking up.

After being demobbed in September 1957 I returned to the freight trains section at Redhill, making very few photographic visits, one of which was to Eastleigh in October. One of the features of National Service was that it broadened one's life experiences, a rite of passage that is similar to nowadays when students spend time at university. Because of this, and a lack of a suitable camera, I did not take photographs for several years, although I still kept up an interest in locomotive movements and withdrawals, etc. It was the realisation in mid-1961 that steam

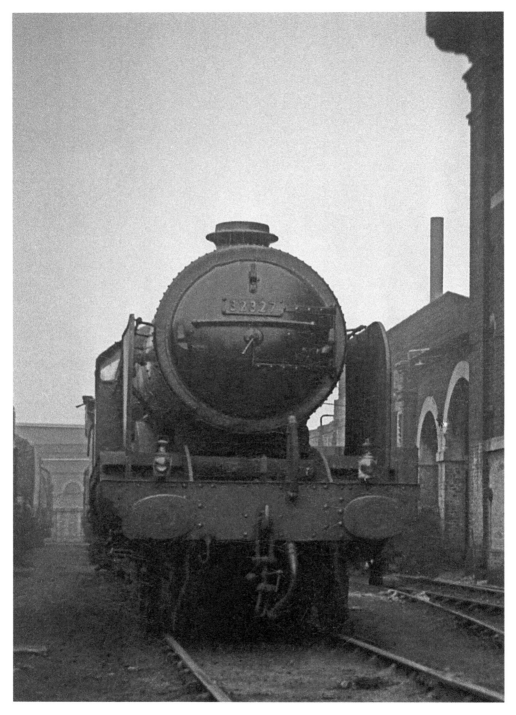

N15/X Class No. 32327 *Trevithick* at Brighton shed, 24 April 1952. Originally built at Brighton as LBSCR L Class 4-6-4 tank No. 327 *Charles C. Macrae*, entering service in April 1914. It was rebuilt as an N15/X 4-6-0 in April 1935.

was rapidly being replaced by diesel and electrification that prompted me to get out and start photographing again whilst the locomotives admired in my schooldays were still active. To this end, I bought a twin-lens reflex camera and set about the task in hand. Shortly after this the Redhill office closed, with the staff members being transferred to the new central divisional manager's office at Essex House Croydon. Now in the Special Traffic Section, I worked not only alongside the same photographer from Redhill but also such Southern photographic luminaries as S. C. Nash and J. J. Smith. I then continued taking railway photographs until the end of 1966, with the exception of a hiatus in 1963. Steam had all but finished, and with it my interest in that field of photography. I had left the Southern Region in mid-1965 and transferred to the British Railways Board, initially at Leeds and then Marylebone, finally leaving railway service in September 1967.

The photograph section that follows documents much of what I saw at Basingstoke and Salisbury between June 1956 and May 1965.

Basingstoke

Basingstoke station is on the former London & South Western Railway lines between Waterloo, Salisbury and Southampton. The railway between London and Southampton was incorporated in the London & Southampton Act of 25 July 1834. Although construction of the railway commenced shortly after the bill was passed, it was not until 10 June 1839 that the line was opened as far as Basingstoke. On the same date the line was opened between Southampton and Winchester. The first station at Basingstoke was, of course, a temporary terminus and did not become a through station until the later opening of the line from Winchester on 11 May 1840. Earlier, in 1839, powers were obtained to construct a line from Eastleigh to Gosport; however, because of objections by the citizens of Portsmouth to the inclusion of the word 'Southampton' in the name of the company serving them, the Act allowed its name to be changed to the 'London & South Western Railway'. The initial idea in 1831 was for a 'Southampton, London & Bristol Branch Railway & Dock Co.', the branch being a route from Basingstoke to Bristol via Newbury and Devizes. Indeed, a bill for the Basingstoke–Bristol line was put forward in 1835, but this route was rejected in favour of the Great Western's London–Bristol line. This proposal was the start of competition between the LSWR and the GWR.

The inter-company competition between the LSWR and the GWR arose again when Newbury expressed a desire to be linked to the railway system, having missed out when the line from Basingstoke to Bristol was rejected and the GWR main line to Bristol routed elsewhere. The LSWR proposed a direct line to Newbury and at the same time the GWR proposed a connection from Pangbourne. Both bills were referred to the House of Commons, who accepted the LSWR route, rejecting that proposed by the GWR. However, the House of Lords reversed that decision, and the GWR bill for the Berks & Hants Railway was passed and incorporated in 1845.

The Berks & Hants Railway had broad-gauge lines from Reading to Newbury and from Reading to Basingstoke, opening 1 November 1848. At Basingstoke there was a separate station, located near to the present Platform 5, and an engine shed. Since the line was built to the broad gauge, Basingstoke became a broad-gauge/standard-gauge interchange station, resulting in a costly operation with a transfer shed having to be built to enable goods to be transferred across a platform from one gauge to the other. By 1854 governmental and business pressure resulted in the

GWR being ordered to convert the line to standard gauge by effectively extending the standard gauge line being built from Birmingham to Oxford by a mixed-gauge track via Didcot and Reading to Basingstoke. After several delays this was finally opened on 22 December 1856, thus creating the link between the Midlands and Southampton, avoiding London, which continues to be a major route today. The GWR had its own station at Basingstoke, to the north of that of the LSWR. This station continued to be used until 1 January 1932, when an additional platform was added to the LSWR station; at the same time, staffing by GWR personnel ceased. The mixed-gauge track remained in situ until 1 April 1869.

The original station at Basingstoke was quite small, and it was not until 1850 that a more substantial structure was built. However, by the time the line to Winchester had opened, a locomotive shed was in operation at Basingstoke; this original shed was to the south of the main line and was closed in 1909 when the station was enlarged. A larger shed was built to the north of the station, and this continued to be used (British Railways code 70D) until closure in March 1963, although use as servicing point continued until the end of steam on the Southern Region in June 1967. Demolition took place during 1969. The GWR also had a small engine shed to the east of the station on the north side of the line. This shed continued to be used until its closure in November 1950, the locomotives from

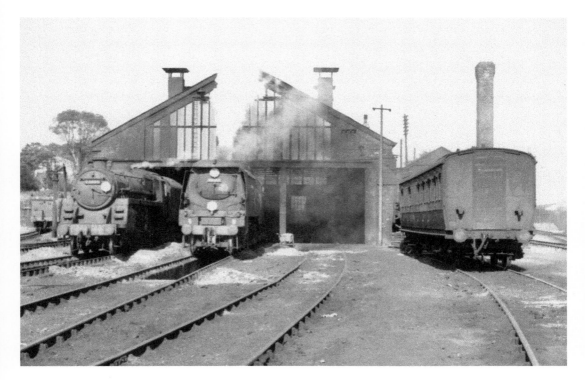

Basingstoke shed, 25 July 1963. On shed are Standard 5 4-6-0 No. 73065 and Battle of Britain Class 4-6-2 No. 34054 *Lord Beaverbrook*. (John Scrase)

then on being dealt with at the former LSWR shed, although there was not a set number of GWR locos allocated to Basingstoke. The use of steam locomotives on the former GWR ceased in 1965 with the closure of Reading shed. Basingstoke never had a large locomotive allocation, duties being mainly local and secondary services. Before the Second World War it had several Adams 4-4-0s from classes T6 and X6 serving their days out, and these included No. 657, which starred in the film *Oh, Mr. Porter!* Withdrawn in 1940, No. 657 rusted away at Eastleigh until being towed to Horley, where it was broken up by Moss Evans in November 1949. This was more than likely one of the engines I saw there when going past during some locospotting in the London area. As stated earlier, the N15/X Class 4-6-0s were at Basingstoke until they were withdrawn, supplemented in 1954 by a few Urie King Arthurs. By 1957 the Arthurs were still there but were about to be replaced by double chimney-fitted BR Class 4 4-6-0s, Maunsell King Arthurs and Schools Class 4-4-0s. When the sheds closed in 1963, all that remained were the Standard 4s and three U Class 2-6-0s.

The LSWR line was then extended to Andover, with the intermediate stations opening on 1 July 1854; finally the line reached Salisbury, where the first through train ran on 2 May 1859. The junction between the routes to Southampton and Salisbury was at Worting. The junction was replaced on 30 May 1897, when the Battledown Flyover west of the signal box at Worting Junction was commissioned. The flyover enabled the Up line from Southampton to pass over those going to Salisbury with the Down line passing to one side. This enabled higher-speed running and avoided delays, with one set of lines crossing the other. Part of these developments providing for the growth of traffic included the quadrupling of the tracks between Clapham Junction and Worting Junction; these workings were completed by 1907 and included the building of the present station at Basingstoke. Meanwhile, in 1902 approval was given for the installation of air-controlled pneumatic signalling between Woking and Worting Junction. New signal boxes at Basingstoke East and West were brought into operation in 1906 to control these signals. These signals were converted to electro-pneumatic operation in 1914, which remained in use until resignalling took place as part of the Bournemouth route electrification completed in 1967. An interesting potential development occurred in 1871 when the LSWR approached Basingstoke town council with a view to building a new carriage and wagon works. However, no agreement was reached and eventually the new works were built at Eastleigh.

The passing of the Light Railways Act in 1896 resulted in the authorisation in December 1897 of the Act for the Basingstoke–Alton line, which opened on 1 June 1901. Traffic was very light and the line was closed on 30 December 1916, the track between Clissesden and Alton Park being removed by April 1917 and taken to France for war use. Alton Park station had been built in 1908 to serve the Lord Mayor Treloar Hospital at Alton and was only used to carry patients. However, after the First World War, the track was restored and the route reopened on 18 August 1924, except for that between Bentworth, Lasham and Alton Park. These services were short lived, since the stations were closed to passengers again

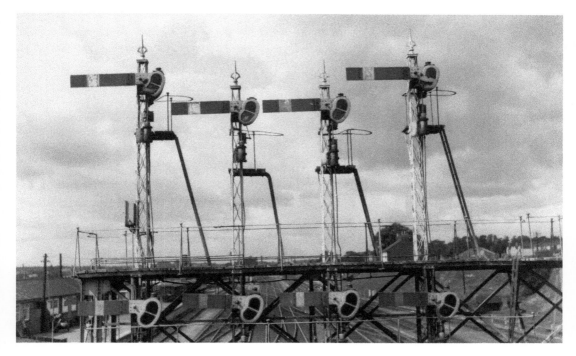

Basingstoke Down home signals, 8 August 1962. (John Scrase)

on 12 September 1932. The line was finally closed to goods traffic on 1 June 1936 and the track removed, except for the private Thornycroft siding at the Basingstoke end and the section serving Alton Park. These two sections were not closed until 1967. Before the track was lifted it was using for the filming of the previously mentioned Will Hay comedy film *Oh, Mr. Porter!* Adams 0395 Class 0-6-0 No. 3509 and X6 Class 4-4-0 No. 657 were used, fitted with I3 class chimneys. Filming took place between May and July 1937 at the former station at Cliddesden, which was renamed 'Buggleskelly'. The locomotive most featured in the film was *Gladstone*, which was, in reality, KESR No. 2 *Northiam*.

The final railway construction at Basinstoke was the 1.5-mile branch to Park Prewitt Mental Hospital. More a long siding than a branch line, it was opened possibly in 1913 and most certainly by February 1914, and was used in the construction of the hospital up until 1916. Out of use by 1948, trains were banned from using it on 30 September 1950. Final closure was in 1954, the track being lifted in 1956.

On 12 November 1966, colour-light signalling was commissioned between Worting Junction and St Denys, followed on 19 November by the commissioning of Basingstoke power signal box and the colour-light signalling between Brookwood and Andover. On 1 January 1967 the line was electrified between Brookwood and Basingstoke, followed on 3 April 1967 by the section from Basingstoke to Bournemouth. This 1966 power signal box covered the lines

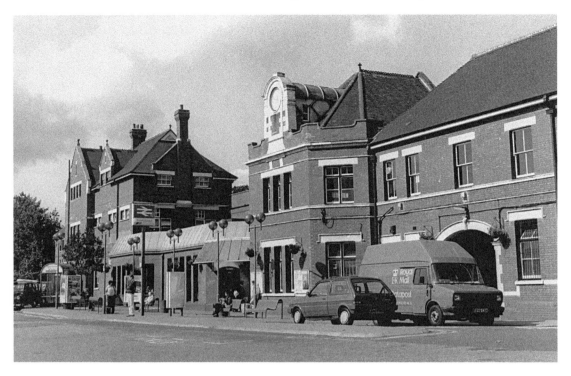

Basingstoke station entrance, 23 September 1988. (John Scrase)

from Woking to Micheldever on the route to Eastleigh and Andover; on the route to Salisbury; and on part of the line towards Reading. This facility was replaced in 2007 when the area was resignalled. In 2013 it was announced that a new Network Rail signalling operation centre would be opened at Basingstoke, which would be responsible for an area from London Waterloo to Weymouth, Portsmouth Harbour and Exeter. A further development will be the potential 25 KVA electrification of the line from Reading. The station entrance at Basingstoke was remodelled in both 1987 and 2012 to cater for increased passenger volumes, which had risen to approximately 5.5 million in 2014/15. It has to be noted that when the railways came to Basingstoke the population was in the order of 4,000; by 2015, this had risen to 83,000. This rise in population is due to Basingstoke becoming an overspill town for London in the early 1960s. Continuous housing developments have seen houses being built as far as Worting.

Basingstoke began as a Saxon village and is mentioned in the Doomsday Book of 1086. By the thirteenth century the village had grown into a small town with weavers and tanners. The town grew gradually over the centuries, although the weaving business was in decline because of competition from the north of England. At the time of the first census in 1801 the population was 2,589. This had almost doubled by 1851, and by 1901 it had risen to 9,510. By the middle of the nineteenth century, manufacturing was becoming important to Basingstoke, with Millwards

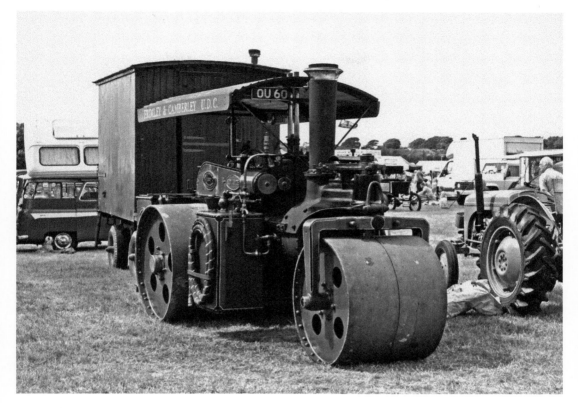

Wallis & Steevens road roller, builder's number 8047, pictured at Ringmer on 28 July 2013. It was first registered in December 1930, as OU6002. It was named *Endeavour*.

making boots and shoes; Wallis & Steevens and Taskers making steam engines and agricultural equipment; and, later in 1897, with Thornycrofts also making engines and subsequently lorries and cars. There is a museum in Basingstoke containing many of these three firms' products. As a town Basingstoke continued to expand and, in 1943, Lansing Bagnall opened a factory that made battery electric trucks. This expansion continues to the present day.

Today Basingstoke enjoys a much more intensive service than it did in the days of steam, with possibly seventeen trains per hour at off-peak times. Gone are the glory days of steam, the Atlantic Coast Express and the Bournemouth Belle, to be replaced by mainly the same types of diesel and electric multiple units to be found throughout the rail network, distinguishable only by the liveries of the various train operating companies. Freights are mainly worked by Class 66 and 67 locomotives.

My first visit to Basingstoke was on 21 June 1956, having been at Salisbury earlier in the day. The first photograph I took was of Lord Nelson Class 4-6-0 No. 30865 *Sir John Hawkins* on a Down Bournemouth service, a regular turn for this class of locomotive. Later on I was to photograph another of the class,

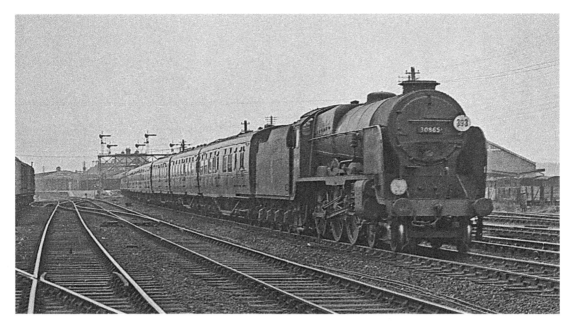

Lord Nelson Class 4-6-0 No. 30865 *Sir John Hawkins* at Basingstoke with a Down Bournemouth service, 21 June 1956.

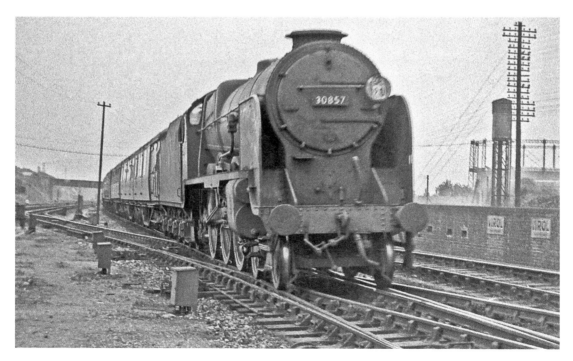

Lord Nelson Class 4-6-0 No. 30857 *Lord Howe* at Basingstoke with a Down Southampton line service, 21 June 1956.

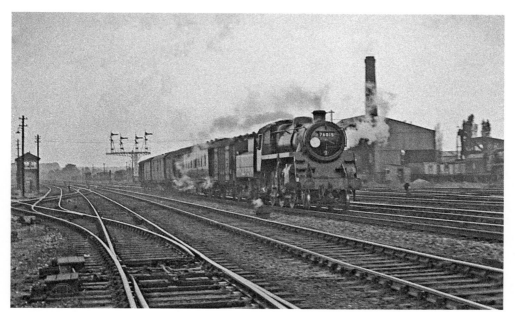

BR Class 4 2-6-0 No. 76015 entering Basingstoke with an Up parcels service on 21 June 1956.

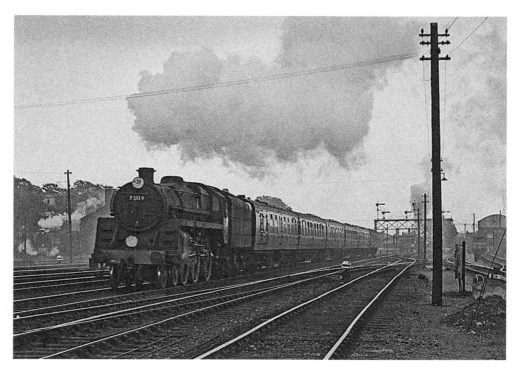

BR Standard 5 4-6-0 No. 73119 at Basingstoke, with a Down semi-fast service to Salisbury on 21 June 1956. It was later named *Elaine*.

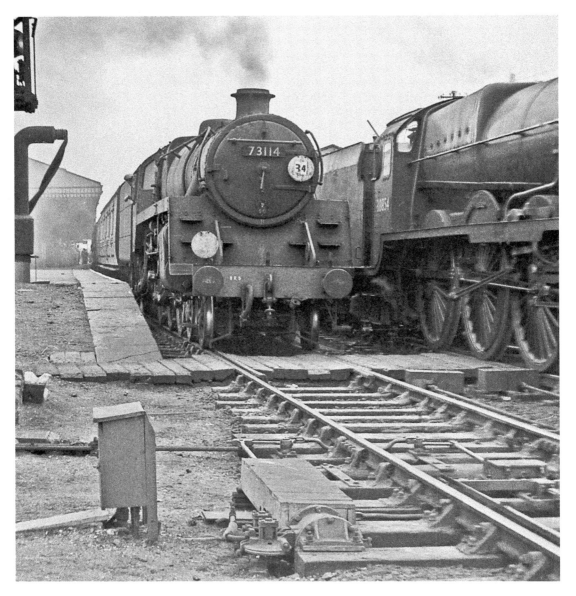

BR Standard 5 4-6-0 No. 73114 at Basingstoke with an Up train from Bournemouth on 21 June 1956, later renamed *Etarre*.

No. 30857 *Lord Howe*, on what I noted as being a Down troop train. By this time many of the workings were hauled by BR Standard designs, including: Class 4 2-6-0 No. 76015, seen on an Up parcels train; Class 5 4-6-0 No. 73119, on a Down semi-fast to Salisbury; and another Class 5, No. 73114, on an Up train routed via Eastleigh. Also seen was Maunsell S15 Class 4-6-0 No. 30839 on a Down freight from Feltham, possibly to Southampton.

My next visit to Basingstoke was not until 4 November 1961, when only three photographs were taken. One was of Ivatt Class 2 2-6-2 tank No. 41275, en route to Eastleigh Works after being transferred from Bletchley. Maunsell King Arthur Class 4-6-0 No. 30804 *Sir Cador of Cornwall* was working the 13.15 empty stock train from Eastleigh to Clapham Junction, while Schools Class 4-4-0 No. 30905 *Tonbridge* was on an Up freight service from Salisbury.

The last visit for 1961 was on a misty 16 November. Again, only three photographs resulted. I walked along the trackside to Worting Junction and firstly

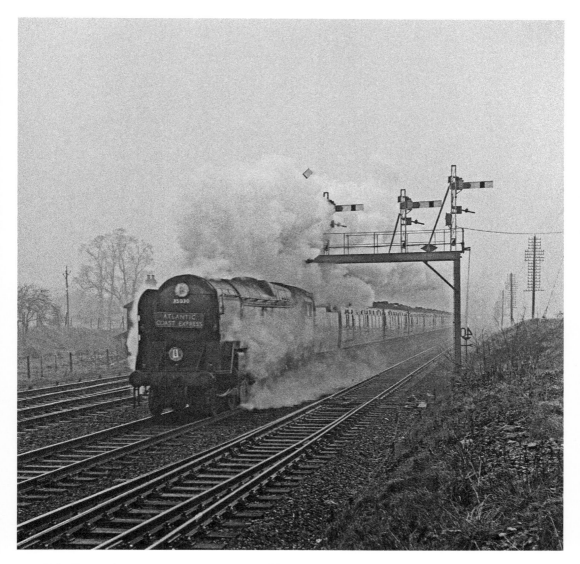

Rebuilt Merchant Navy 4-6-2 No. 35030 *Elder Dempster Lines* near Worting Junction with the Down Atlantic Coast Express, 16 December 1961.

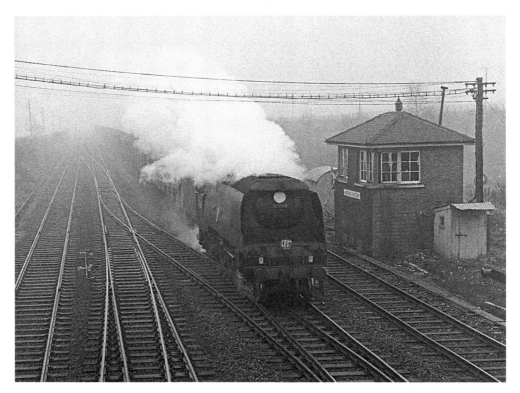

Battle of Britain Class 4-6-2 No. 34068 *Kenley* passing Worting Junction signal box with the 08.10 freight from Templecombe to Feltham, 16 December 1961.

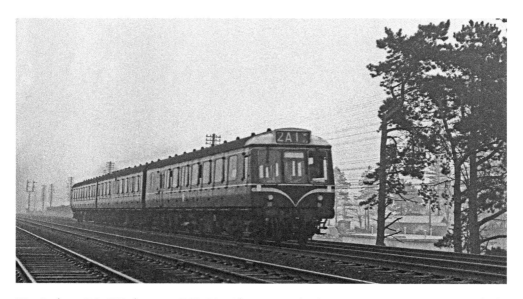

Birmingham R&CW three-car DEMU with W51315 leading near Worting Junction with the 11.53 Portsmouth–Reading General, 16 December 1961.

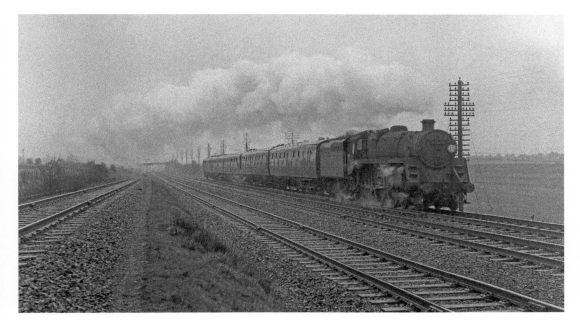

Standard 5 4-6-0 No. 73110 *The Red Knight*, near Battledown with the 09.54 Waterloo–Southampton service, 10 March 1962.

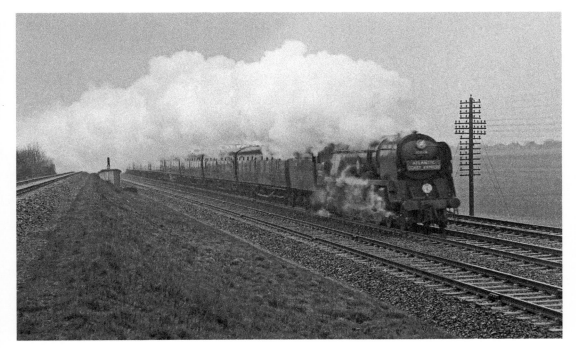

Merchant Navy Class 4-6-2 No. 35020 *Bibby Line* near Worting Junction with the Down Atlantic Coast Express, 10 March 1962.

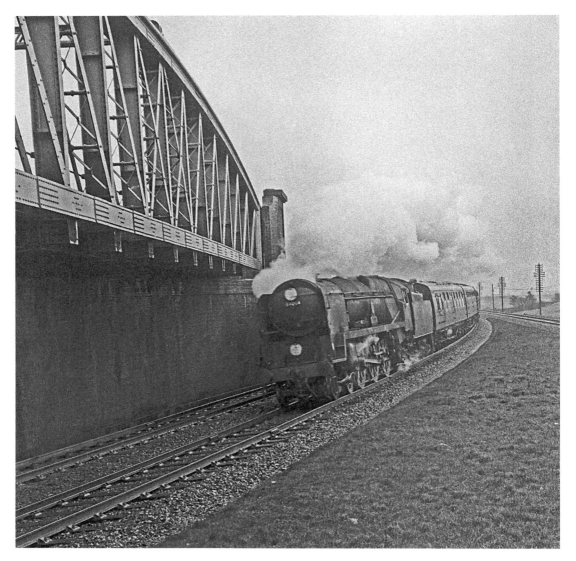

Rebuilt West Country Class 4-6-2 No. 34004 *Yeovil*, near Battledown with the 10.54 Waterloo–Salisbury, 10 March 1962.

saw Merchant Navy Class 4-6-2 No. 35030 *Elder Dempster Lines* emerging with the Down Atlantic Coast Express. Then Battle of Britain Class 4-6-2 No. 34068 *Kenley* was seen passing the signal box, complete with the signalman's moped, on the 08.10 freight from Templecombe to Feltham. Finally, diesel railcars had taken over some of the services to and from the Western Region with BRCW two-car unit W51315 working the 11.53 Portsmouth Harbour–Reading General service.

A gloomy 10 March was my first visit to Basingstoke in 1962. I had caught an early train down from Waterloo, having decided to walk trackside to the flyover

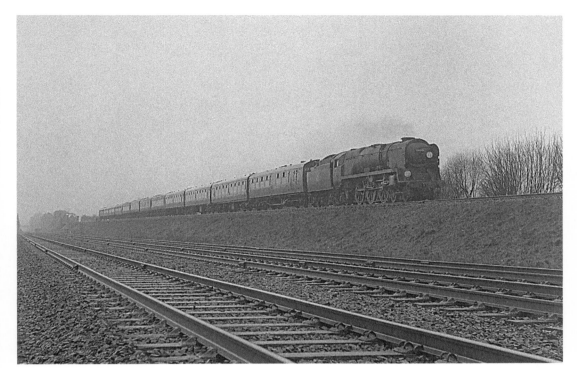

Rebuilt West Country Class No. 34029 *Lundy* on the 09.55 special Poole–Wembley service,
10 March 1962.

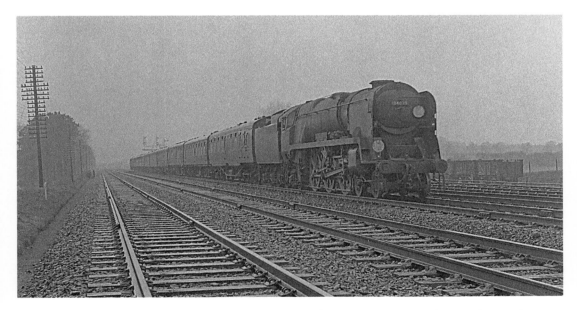

Rebuilt West Country No. 34039 *Boscastle* works the 08.30 Bournemouth–Waterloo service,
10 March 1962.

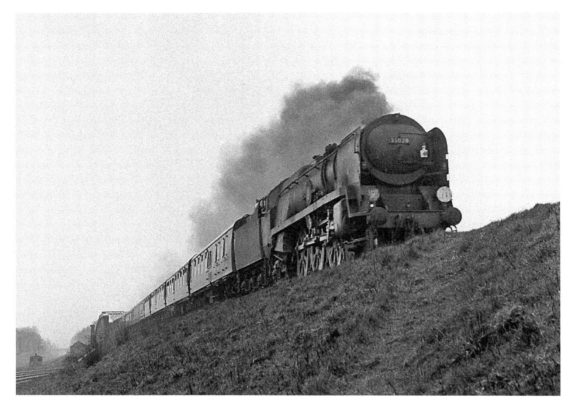

Merchant Navy No. 35028 *Clan Line* drops down from the Battledown Flyover with the 09.17 Weymouth–Waterloo service, 10 March 1962.

at Battledown. One of the services photographed when almost at Battledown was the 09.54 Waterloo–Southampton, hauled by Standard Class 5 4-6-0 No. 73110 *The Red Knight*. Later Merchant Navy Class 4-6-2 No. 35020 *Bibby Line* was photographed on the Down Atlantic Coast Express, followed by rebuilt West Country Class 4-6-2 No. 34004 *Yeovil* on the 10.54 Waterloo–Salisbury service. Several Up expresses were seen, including: rebuilt West Country Class 4-6-2 No. 34029 *Lundy* on the 09.55 special from Poole to Wembley, possibly for a schoolboy football international match; another rebuilt West Country No. 34039 *Boscastle* on the 08.30 Bournemouth–Waterloo service; and Merchant Navy Class 4-6-2 No. 35028 *Clan Line* on the 09.17 Weymouth–Waterloo service. Two other Up services seen closer to Basingstoke were Urie S15 Class 4-6-0 No. 30500 on the 08.20 freight from Eastleigh to Basingstoke and Hall Class 4-6-0 No. 5906 *Lawton Hall* with the 10.07 Southampton Terminus–Reading General. With no signs of the weather improving, I then called it a day.

It was not until 30 June that I next went to Basingstoke, travelling down from Waterloo on a lunchtime service hauled by the recently restored T9 Class 4-4-0 No. 120. This was a regular turn for this locomotive, except when on Rail Tour

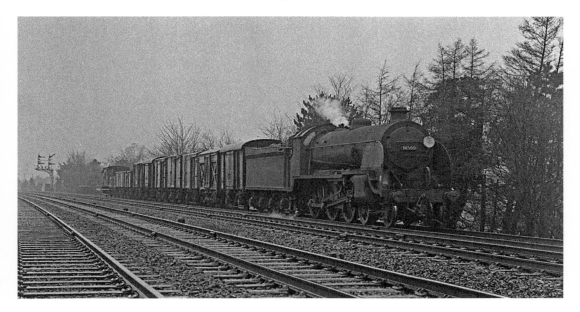

Urie S15 Class 4-6-0 No. 30500 on the 08.20 freight service from Eastleigh to Basingstoke, 10 March 1962.

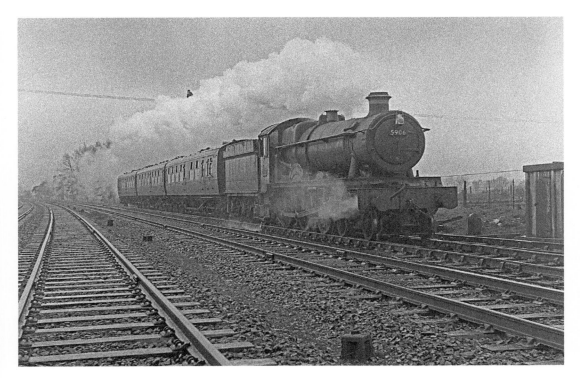

Hall Class 4-6-0 No. 5906 *Lawton Hall* near Basingstoke with the 10.07 Southampton Terminus–Reading General service, 10 March 1962.

duties. What was really interesting was the number of families standing in their back gardens to wave as the old girl went past. A number of locos were seen on shed, including Hall Class 4-6-0 No. 5973 *Rolleston Hall*, Urie S15 No. 30515 and Standard 5 4-6-0 No. 73112 *Morgan Le Fay*. Also on shed were 700 Class 0-6-0 No. 30368 *Pride of Basingstoke* and Schools Class 4-4-0 No. 30934 *St Lawrence*. The latter was the last of that class to be in steam in BR days when, on 18 May 1963, after being withdrawn at the end of December 1962, it hauled No. 30368 to Eastleigh for breaking up. Merchant Navy Class No. 35021 *New Zealand Line* worked the 13.00 Waterloo–Weymouth service after overtaking Urie S15 No. 30508 on the 13.24 Waterloo–Salisbury. Several inter-region services followed, including Standard 4 2-6-0 No. 76064 on the 08.55 Sheffield–Bournemouth service, King Arthur Class No. 30793 *Sir Ontzlake* on the 12.38 Portsmouth–Birmingham service and Lord Nelson Class No. 30856 *Lord St Vincent* on the 13.11 Portsmouth–Birmingham service. Up trains seen included the rebuilt Battle of Britain Class 4-6-2 No. 34056 *Croydon*, working the 08.30 Padstow–Waterloo; another rebuilt Battle of Britain Class, No. 34052 *Lord Downing,* with the 12.56 empty stock from Bournemouth to Willesden; Merchant Navy Class No. 35009 *Shaw Savill* with the 13.28 Lymington–Waterloo service; and finally another Merchant Navy No. 35010 *Blue Star* with the Up Atlantic Coast Express. Overall, it was a good afternoon with a variety of steam locomotive types.

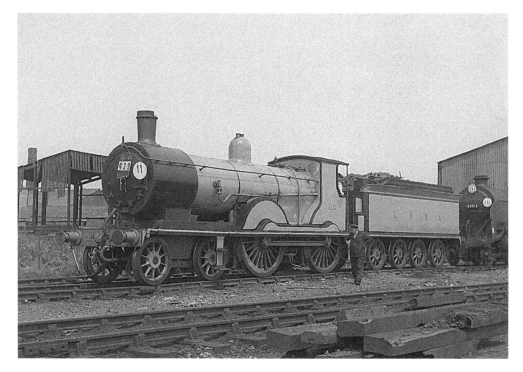

T9 Class 4-4-0 No. 120 at Basingstoke shed on 30 June 1962, restored and in LSWR livery.

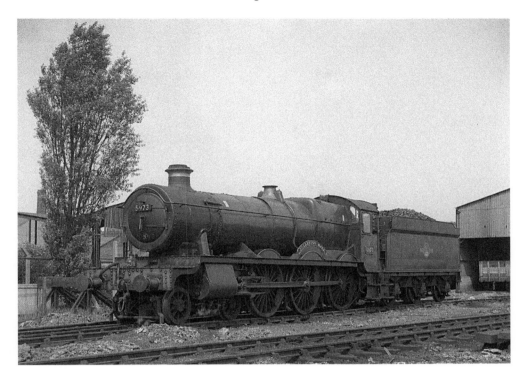

Hall Class 4-6-0 No. 5973 *Rolleston Hall,* Basingstoke shed, 30 June 1962.

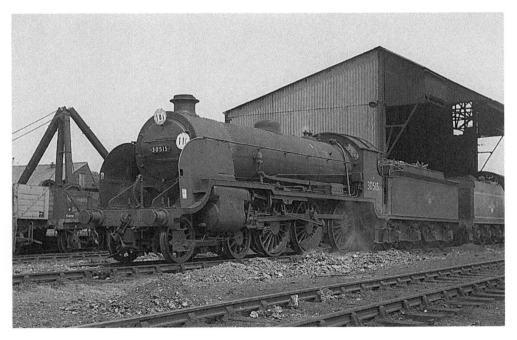

Urie S15 Class 4-6-0 No. 30515 at Basingstoke shed, 30 June 1962.

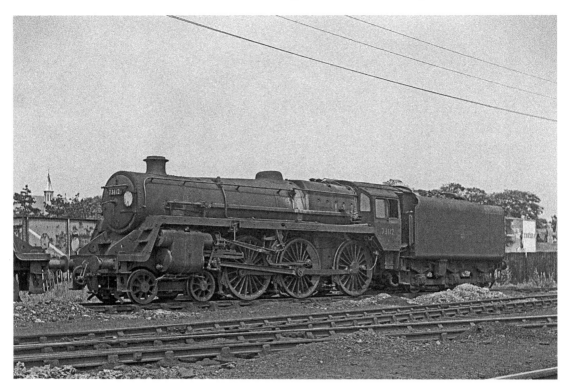

Standard 5 4-6-0 No. 73112 *Morgan le Fay* at Basingstoke shed, 30 June 1962.

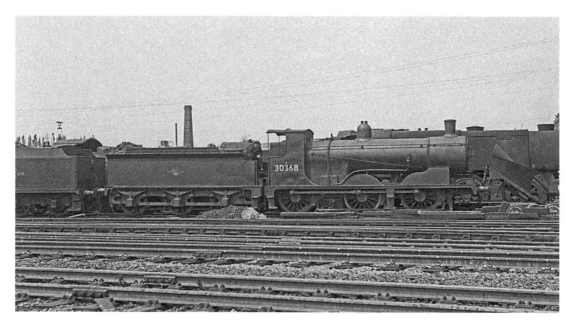

700 Class 0-6-0 No. 30368 *Pride of Basingstoke* at Basingstoke shed, 30 June 1962.

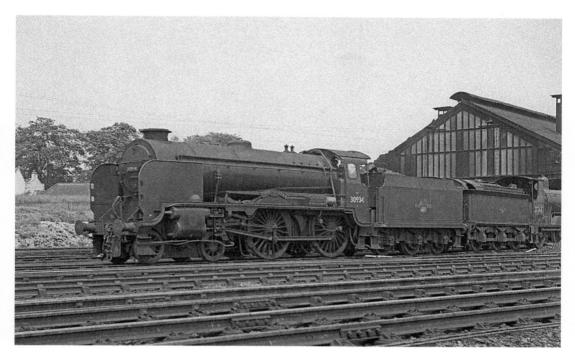

Schools Class 4-4-0 No. 30934 *St Lawrence* at Basingstoke shed, 30 June 1962.

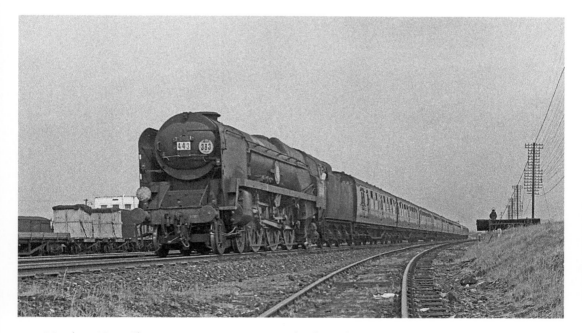

Merchant Navy Class 4-6-2 No. 35021 *New Zealand Line* heads the 13.30 Waterloo–Weymouth service on 30 June 1962, west of Basingstoke. The line in the foreground veering to the left is the remains of the branch to Alton.

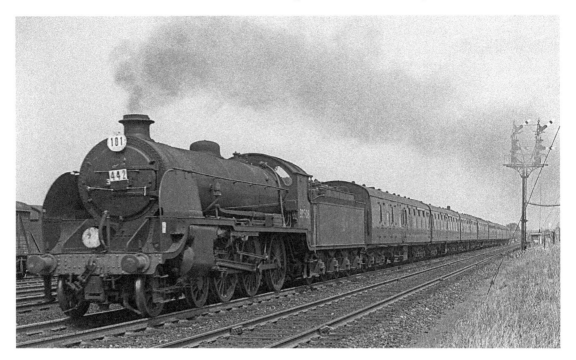

Urie S15 Class No. 30508 leaves Basingstoke with the 13.24 Waterloo–Salisbury service on 30 June 1962.

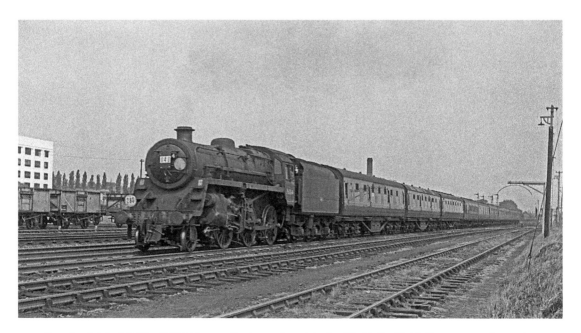

Standard 4 2-6-0 No. 76064 leaves Basingstoke with the 08.55 Sheffield–Bournemouth service on 30 June 1962.

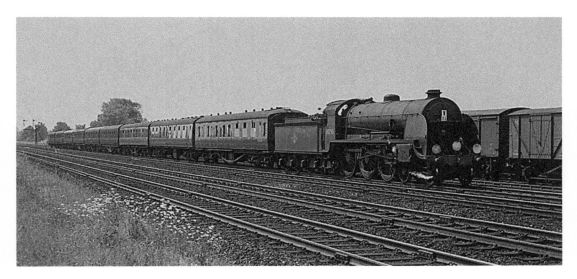

King Arthur Class 4-6-0 No. 30793 *Sir Ontzlake* approaches Basingstoke with the 12.38 Portsmouth–Birmingham service on 30 June 1962.

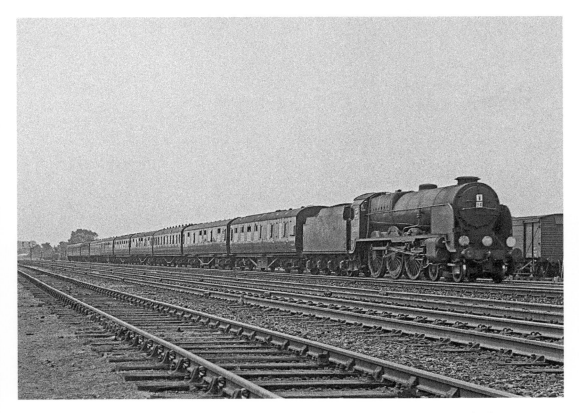

Lord Nelson Class 4-6-0 No. 30956 *Lord St Vincent* nears Basingstoke with the 13.11 Portsmouth–Birmingham service on 30 June 1962.

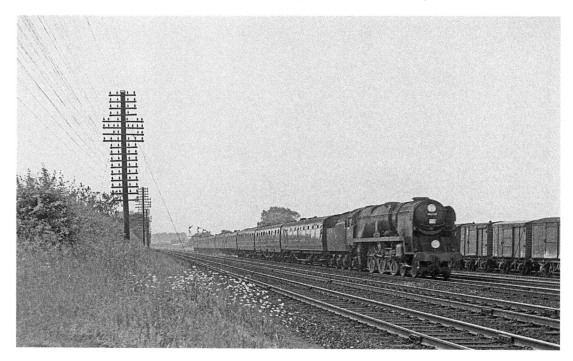

Rebuilt Battle of Britain Class 4-6-2 No. 34058 *Croydon* nears Basingstoke with the 08.30 Padstow–Waterloo service on 30 June 1962.

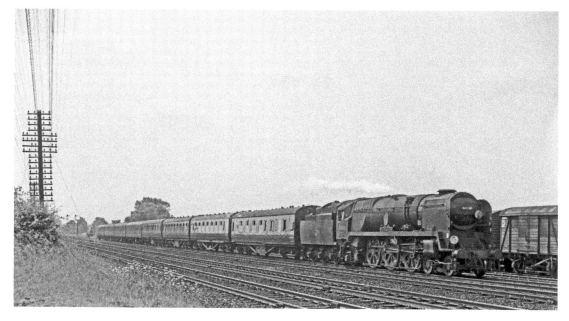

Rebuilt Battle of Britain Class No. 34052 *Lord Downing* nears Basingstoke with the 12.56 empty stock working from Bournemouth to Willesden, 30 June 1962.

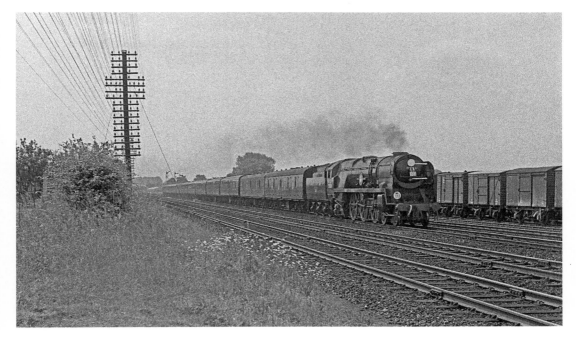

Merchant Navy Class No. 35009 *Shaw Savill* nears Basingstoke with the 13.28 service from Lymington to Waterloo on 30 June 1962.

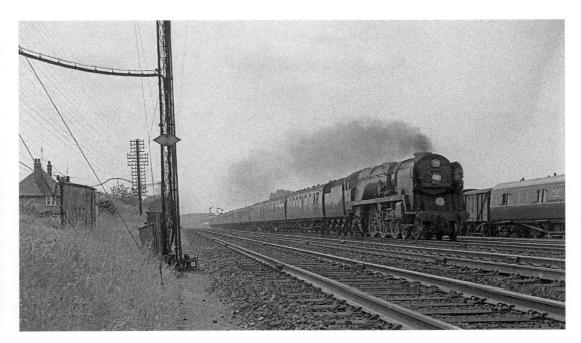

Merchant Navy Class No. 35010 *Blue Star* nears Basingstoke with the Up Atlantic Coast Express on 30 June 1962.

Saturday 1 September was the last Saturday of the 1962 summer timetable and promised several additional services. Therefore I arrived at Basingstoke earlier than normal to get as many photographs as I could. On shed was Grange Class 4-6-0 No. 6833 *Calcott Grange* waiting to take over an inter-regional service. A surprise was Schools Class No. 30925 *Cheltenham*, travelling at some speed with the 10.15 Waterloo–the West of England service. With a load of ten coaches *Cheltenham* worked through to Exeter Central, arriving three minutes early. Rebuilt West Country No. 34010 *Sidmouth* worked what I noted as being the 09.15 Waterloo–the West of England service, seen near to Worting Junction; I think the service details were incorrectly recorded since it would not have been possible for me to have got to Worting by that time. Urie S15 Class 4-6-0 No. 30512 was photographed near Worting Junction with the 10.45 Waterloo–the West of England, followed by Merchant Navy Class No. 35014 *Nederland Line* on the Down Atlantic Coast Express. On the 11.22 Waterloo–Weymouth service was rebuilt West Country Class No. 34046 *Braunton*, seen passing Hampshire DEMU No. 1133 on the 11.53 Reading General–Southampton Terminus. Travelling in the reverse direction was Battle of Britain Class No. 34081 *92 Squadron* with the 09.30 Exmouth–Waterloo service; the DEMU can be seen disappearing in the background. Still in the Worting area Urie S15 No. 30497 was working the 11.54 Waterloo–Salisbury service. Going further down to Battledown, Merchant Navy No. 35013 *Blue Funnel* was seen on the Up Atlantic Coast Express. Meanwhile Grange No. 6833 *Calcott Grange* had taken over the 08.43 Wolverhampton–Portsmouth service; an earlier Up service was West Country No. 34041 *Wilton* on the 09.42 service from Bournemouth to Birkenhead. An interloper, forecasting what was to follow in later years, was Crompton Bo-Bo diesel-electric D6583 on the 11.15 service from Southampton Docks to Waterloo, followed by Lord Nelson 4-6-0 No. 30861 *Lord Anson* on the 11.51 Southampton Docks–Waterloo service. Also seen was rebuilt West Country No. 34022 *Exmoor* working the 10.00 Bournemouth–Waterloo service. Up services were coming thick and fast, including King Arthur Class No. 30782 *Sir Brian* on the 09.40 Ilfracombe–Waterloo, West Country No. 34006 *Bude* on the 09.20 Swanage–Waterloo service, and Schools Class No. 30936 *Cranleigh* with the 13.28 Lymington–Waterloo service. An earlier Up train was the 13.01 Salisbury–Waterloo service hauled by Maunsell S15 Class No. 30826. No. 34041 *Wilton* had also returned, this time on the 09.30 service from Birkenhead to Bournemouth. Finally, after walking back to Basingstoke, on shed were N Class No. 31813, Standard 4 4-6-0 No. 75068 and Hall Class No. 5990 *Dorford Hall*, the latter probably after working the 08.43 from Wolverhampton. This concluded an interesting day.

My last visit in 1962 to Basingstoke was on 27 October. I had been to Eastleigh and called in on the way home. Only two photographs were taken, both at the sheds. The first was of U Class 2-6-0 No. 31633, formerly allocated there, and the last King Arthur in service, No. 30770 *Sir Priaius*.

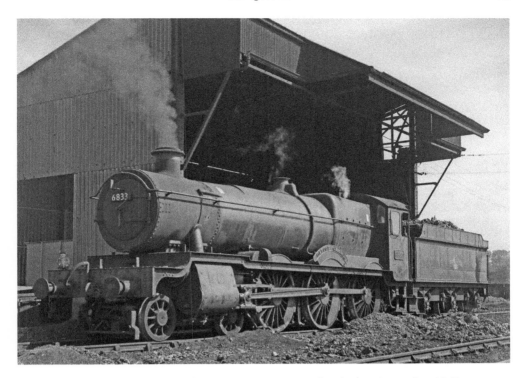

Grange Class 4-6-0 No. 6833 *Calcot Grange* at Basingstoke Shed, 1 September 1962.

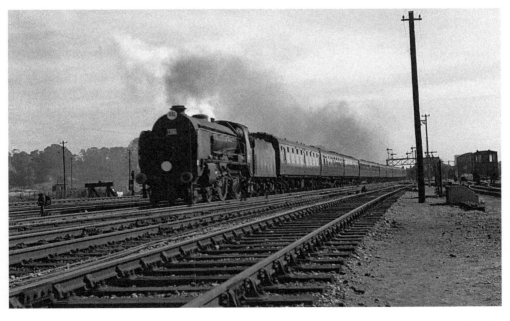

Schools Class 4-4-0 No. 30925 *Cheltenham*, near Basingstoke with the 10.15 Waterloo–the West of England service, 1 September 1962.

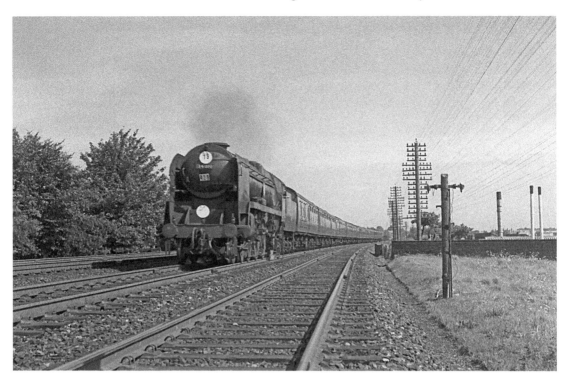

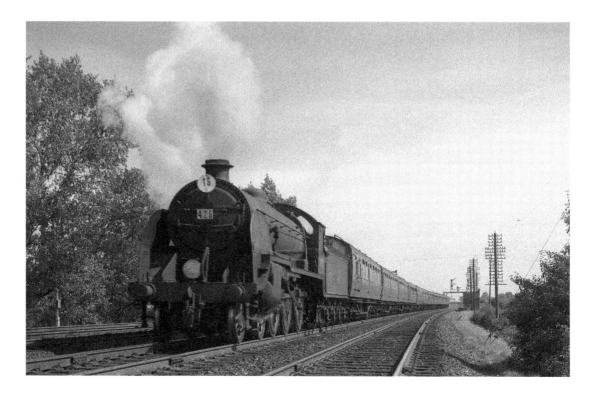

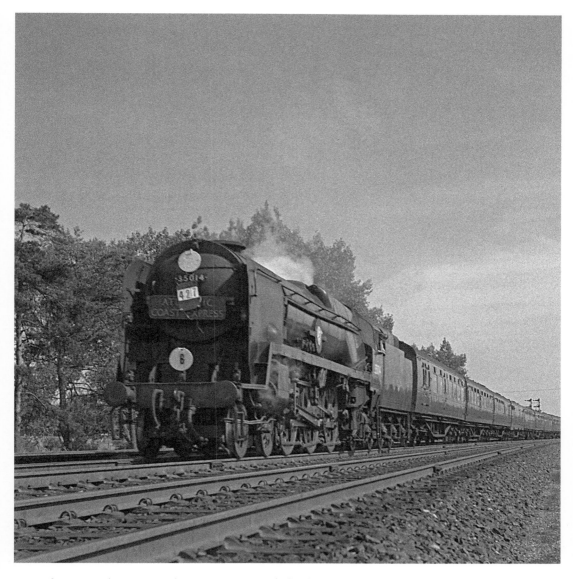

Above: Merchant Navy Class No. 35014 *Nederland Line* near Worting Junction with the Down Atlantic Coast Express on 1 September 1962.

Opposite above: West Country Class No. 34010 *Sidmouth* near Worting Junction, with what is possibly the 09.15 Waterloo–West of England service on 1 September 1962.

Opposite below: Urie S15 Class 4-6-0 No. 30512 is near Worting Junction with the 10.45 Waterloo–West of England service on 1 September 1962.

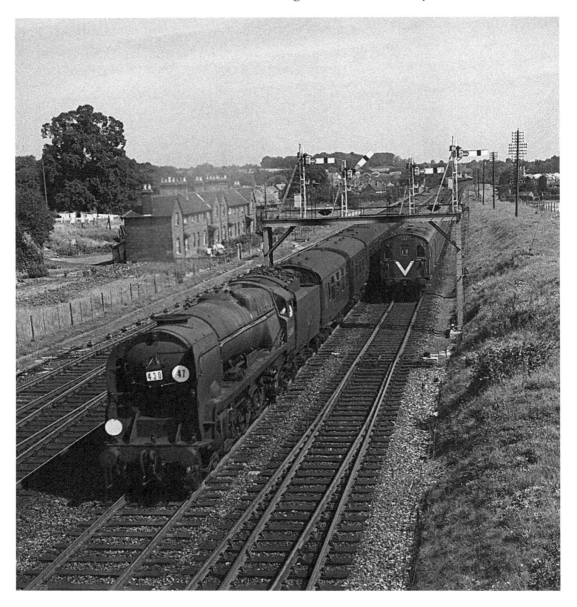

Above: Rebuilt West Country Class No. 34046 *Braunton* at Worting Junction on the 11.22 service from Waterloo to Weymouth passes DEMU 1133 on the 11.53 Reading General–Southampton Terminus on 1 September 1962.

Opposite above: Battle of Britain Class No. 34081 *92 Squadron* passes Worting Junction signal box with the 09.30 Exmouth–Waterloo service with DEMU 1133 in the background, 1 September 1962.

Opposite below: Urie S15 Class No. 30497 near Worting Junction on the 11.54 Waterloo–Salisbury, 1 September 1962.

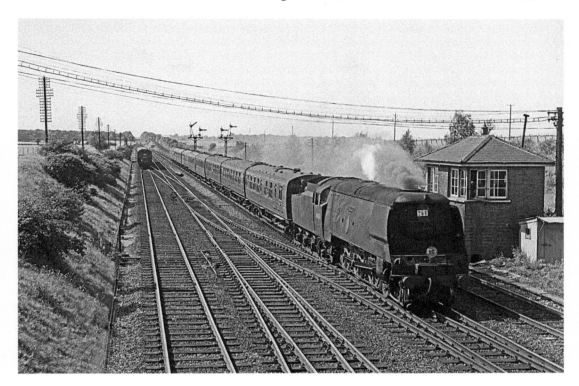

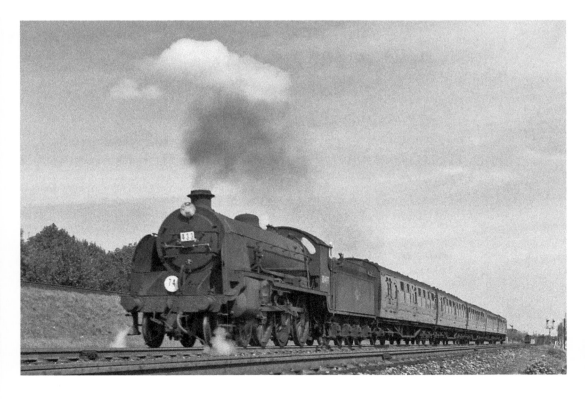

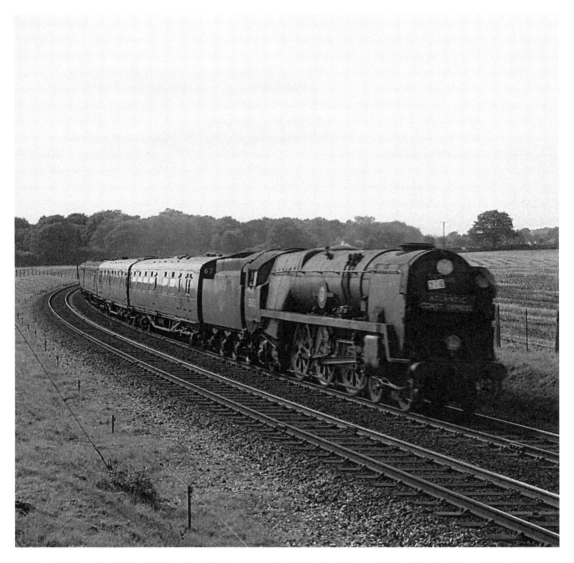

Above: Merchant Navy Class No. 35013 *Blue Funnel* at Battledown with the Up Atlantic Coast Express, 1 September 1962.

Opposite above: Grange Class No. 6833 *Calcot Grange* near Worting Junction with the 08.43 Wolverhampton–Portsmouth on 1 September 1962.

Opposite below: West Country Class No. 34041 *Wilton* near Worting Junction with the 09.42 service from Bournemouth to Birkenhead on 1 September 1962.

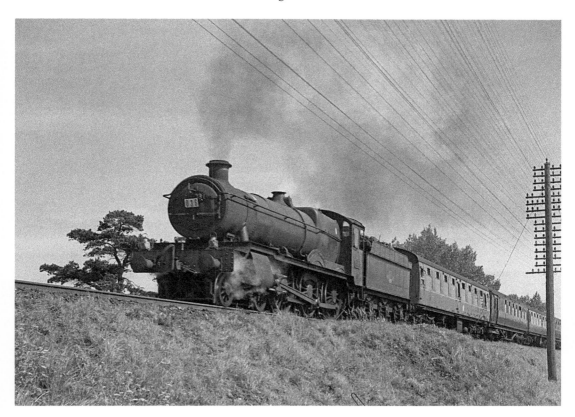

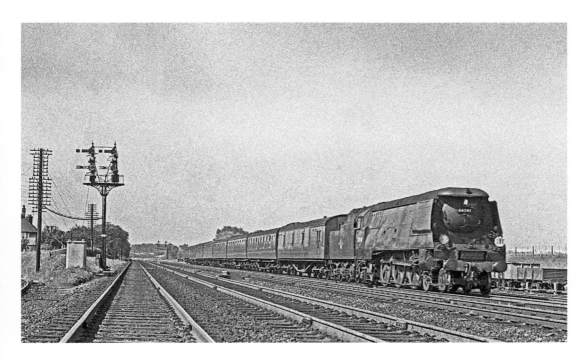

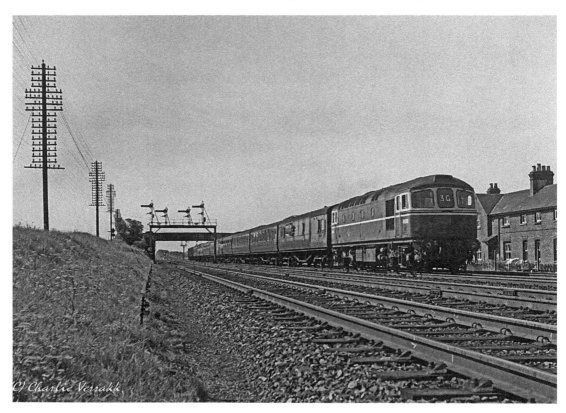

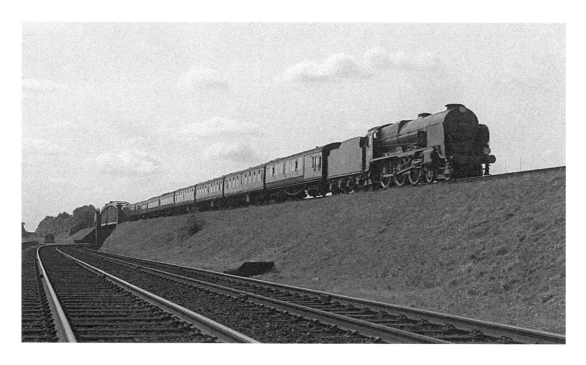

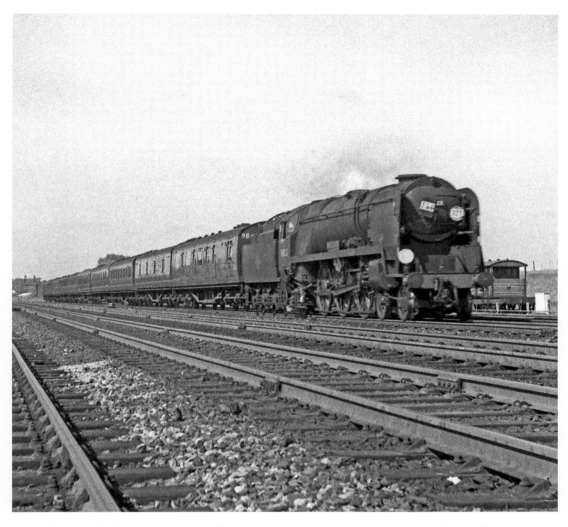

Above: Rebuilt West Country Class No. 34022 *Exmoor* near Basingstoke on the 10.00 Bournemouth–Waterloo service on 1 September 1962.

Opposite above: BRCW Bo-Bo diesel-electric D6583 at Battledown with the 11.15 service from Southampton Docks to Waterloo on 1 September 1962.

Opposite below: Lord Nelson Class No. 30861 *Lord Anson* at Battledown with the 11.51 Southampton Docks–Waterloo service on 1 September 1962.

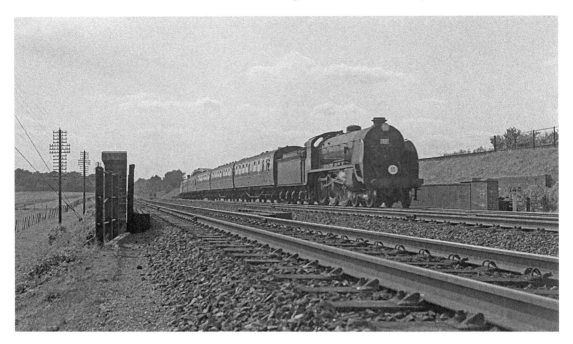

King Arthur Class No. 30782 *Sir Brian* near Battledown on the 09.40 Ilfracombe–Waterloo service, 1 September 1962.

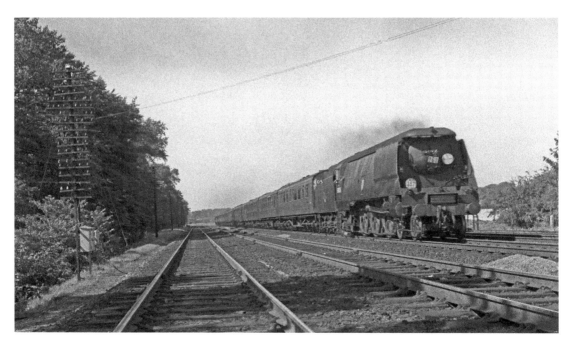

West Country Class No. 34006 *Bude* near Basingstoke with the 09.20 Swanage–Waterloo service, 1 September 1962.

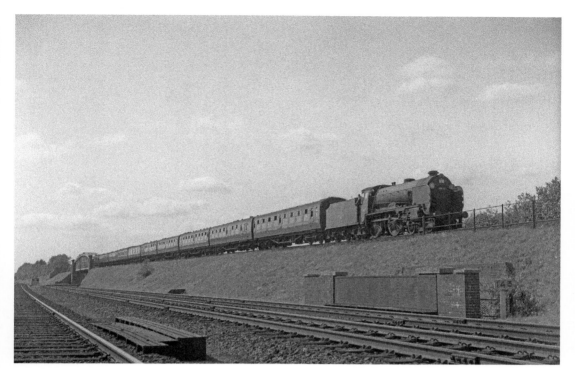

Schools Class No. 30936 *Cranleigh* near Battledown with the 13.28 Lymington–Waterloo line, 1 September 1962.

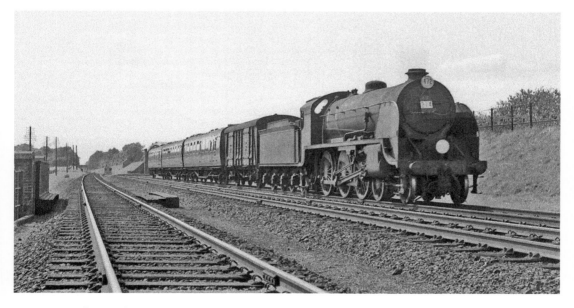

Maunsell S15 Class 4-6-0 No. 30826 near Worting Junction with the 13.01 Salisbury–Waterloo service, 1 September 1962.

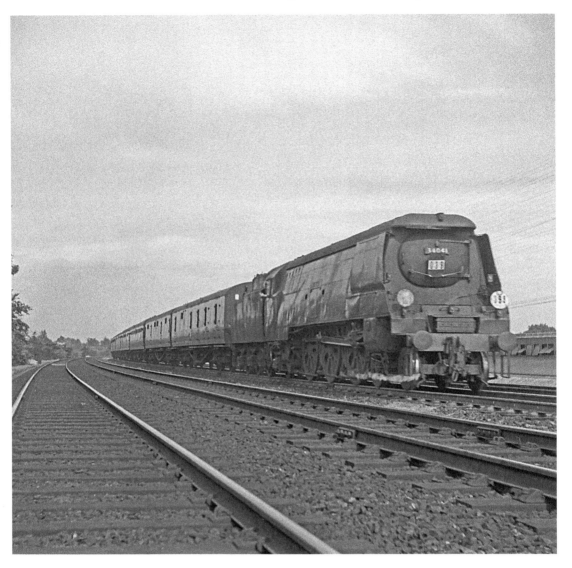

Above: West Country Class No. 34041 *Wilton* near Basingstoke with the 09.30 Birkenhead–Bournemouth service on 1 September 1962.

Opposite above: N Class 2-6-0 No. 31813 on Basingstoke shed, 1 September 1962.

Opposite below: Standard 4 4-6-0 No. 75068 on Basingstoke shed, 1 September 1962.

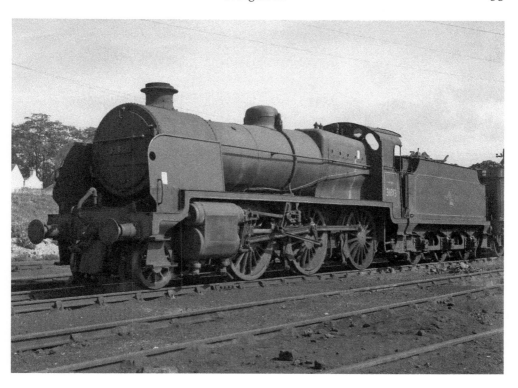

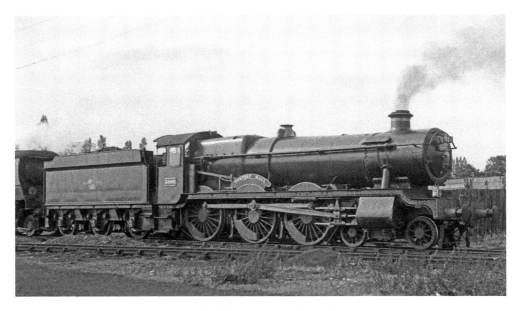

Hall Class 4-6-0 No. 5990 *Dorford Hall* on Basingstoke shed, 1 September 1962.

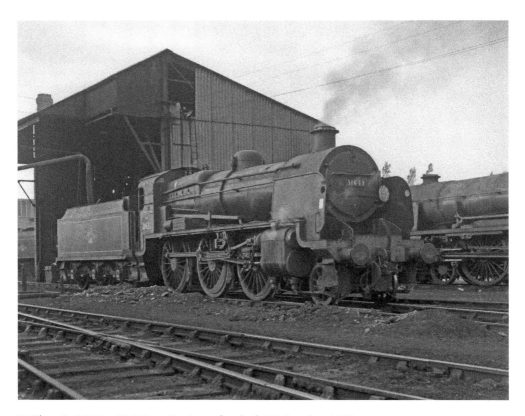

U Class 2-6-0 No. 31633 on Basingstoke shed, 27 October 1962.

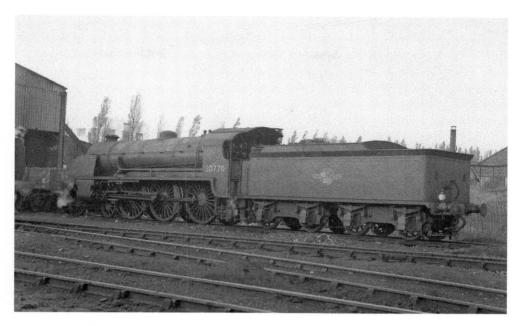

King Arthur Class 4-6-0 No. 30770 *Sir Prianius* on Basingstoke shed, 27 October 1962.

It was not until 16 May 1965 that I was to visit Basingstoke again, in what in fact would prove to be the final visit. I was only there for a short while, concentrating on the approaches from the Waterloo direction and taking a short walk on the Berks & Hants line towards Reading. Gone were the King Arthur, Lord Nelson and Schools classes of locomotives – they had all been withdrawn by the end of 1962. Just after getting to Basingstoke, rebuilt Battle of Britain Class No. 34050 *Royal Observer Corps* was seen working the 09.24 Waterloo–Bournemouth service. Since it had entered service in December 1946, No. 34050 had qualified for a twelve-year ROC long service medal and on 2 June 1961 replica plaques were affixed to the cab sides. Shortly afterwards rebuilt West Country No. 34048 *Crediton* was seen on the 09.30 service from Waterloo to Bournemouth. 6100 Class 2-6-2 tank No. 6165 came off the Berks & Hants line with the 09.45 freight from Reading. Another Down service, the 09.54 from Waterloo to Southampton, was worked by Standard 5 4-6-0 No. 73046. Another rebuilt Battle of Britain seen was No. 34071 *601 Squadron* on the 10.22 Waterloo–Weymouth service, followed by the rebuilt No. 34090 *Sir Eustace Missenden, Southern Railway* on the 10.30 Waterloo–Weymouth service. There was yet another Weymouth service, the 10.36 from Waterloo, which was hauled by Merchant Navy No. 35016 *Belgian Marine*. I then walked up the Berks & Hants branch towards Reading. By now the Somerset & Dorset line via Templecombe had closed and the remaining services from that route were diverted via Basingstoke and Reading. I saw two services on the B&H that day: West Country Class No. 34102 *Lapford* on the 10.00 Bournemouth–York

service, the 'Pines Express', and Type 4 Co-Co diesel-electric D1694 on the 08.43 Birmingham–Bournemouth service. Returning to Basingstoke station, Standard 4 4-6-0 No. 75002 was seen on an Up train; this locomotive had recently been overhauled at Eastleigh and was later to return to its home shed of Machynlleth. I had photographed this particular locomotive before during a visit to Swindon on 18 June 1956, a few days before my first visit to Basingstoke. This finished the visits I had made to Basingstoke. By this date the majority of the Waterloo–the West of England services were hauled by Warship Class Bo-Bo diesel-hydraulic locomotives, terminating at Exeter, although the Atlantic Coast Express with through coaches continued until 4 September 1964.

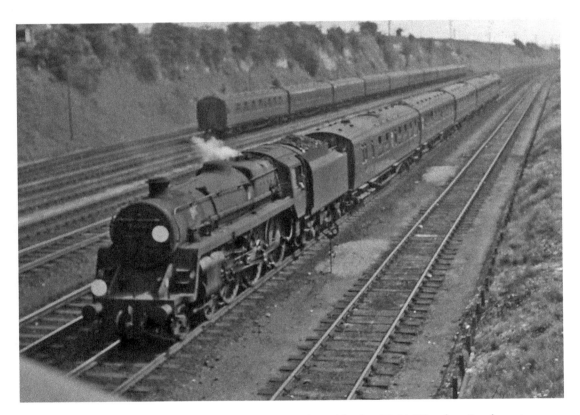

Above: Standard 5 No. 73046 enters Basingstoke with the 09.54 Waterloo–Southampton service, 16 May 1964.

Opposite above: West Country No. 34102 *Lapford* leaves Basingstoke with the 10.00 Pines Express Bournemouth–York service, 16 May 1964.

Opposite below: Type 4 Diesel D1694 nears Basingstoke with the 08.43 Birmingham–Bournemouth service, 16 May 1964.

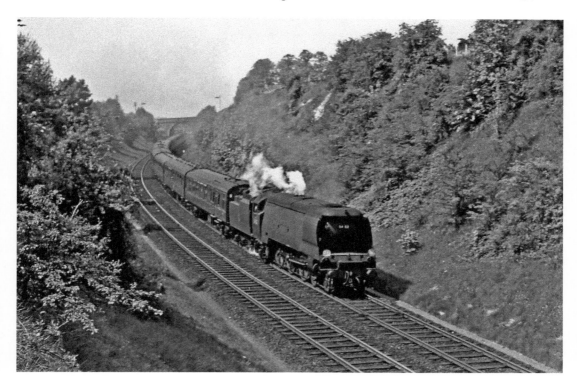

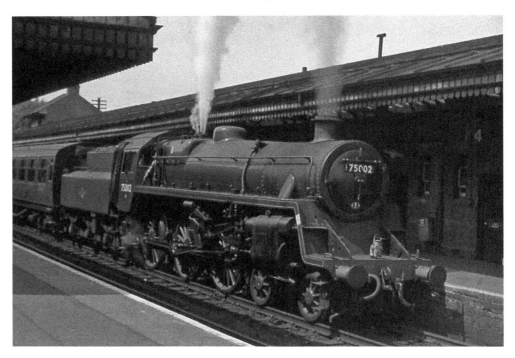

Standard 4 4-6-0 No. 75002 ex-works at Basingstoke with an Up train, 16 May 1964.

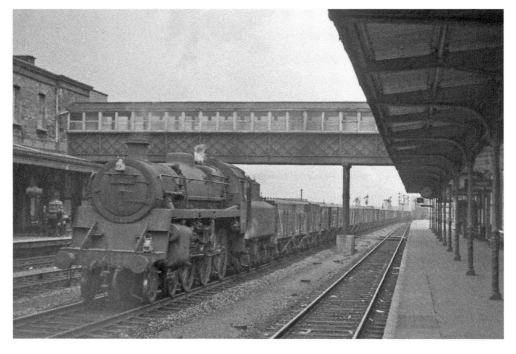

Standard 4 4-6-0 No. 75002 passes through Swindon with a Down freight, 18 June 1956.

Salisbury

The cathedral city of Salisbury could not be reached by rail until 27 January 1847, when a branch line from Bishopstoke, now named Eastleigh, via Romsey was opened for freight traffic, the station at Salisbury being located at Milford, east of the city. The Act for this line was authorised on 4 July 1844; however, construction was delayed due to difficulties in land purchases and an underfunded contractor being unable to complete the works in a timely fashion. Furthermore there were problems with flooding of the earthworks. The line was finally opened for passengers on 1 March 1847, with a small engine shed being located at Milford.

Following the opening of the line from Bishopstoke it became possible for passengers to travel to Salisbury from Nine Elms (Waterloo station was not to open until 11 July 1848), changing at Bishopstoke, with the fastest journey being 3 hours, 50 minutes. As early as 1839 proposals were mooted for a direct line from Salisbury to London, and an early proposal was the branch from the Basingstoke–Southampton line from near Winchester. As with many of the proposals of that time, nothing came of this. In the meantime residents of Andover had become impatient with the lack of progress in connecting them with London and formed the London, Salisbury & Yeovil Co. The LSWR itself had already put in place a proposal for a line from Basingstoke to Salisbury that would bypass Andover. As result of much discussion the necessary finances were raised to commence the construction of the line from Basingstoke to Salisbury, following the Bill succeeding on 13 August 1846. Earlier the LS&Y Bill failed in the House of Lords. Work on this route commenced during December 1847, although rising costs, especially in the purchase of land, resulted in the suspension of work in October 1848, not having yet reached Andover. After several delays Andover was finally reached in 1854, and Salisbury eventually on 1 May 1857. The Salisbury terminus at Milford was reached by setting back from Milford Junction.

In the meantime several proposals had been submitted for a route from Salisbury to Exeter via Yeovil. This resulted in the authorisation on 7 August 1854 of the Salisbury & Yeovil Railway. As part of this, the LSWR had given undertakings to extend to Exeter, and these undertakings were part of the Act obtained on 21 July 1856. The development of this route progressed reasonably well, with the line opened as far as Gillingham, Dorset, on 1 May 1859; Sherbourne was reached on 7 May 1860, and Yeovil on 1 June 1860. Finally, the section from Yeovil to

Exeter Queen Street was opened on 19 July 1860. Concurrently with the opening of the line to Gillingham, the LSWR opened a new station at Salisbury, Fisherton, to the south of the GWR station; at the same time the LSWR Milford station was closed, although it was kept open for goods traffic. Originally the route to Exeter was single line only; however, it was progressively doubled in stages between October 1861 and October 1867. Incidentally the line from Basingstoke was also single line only, and doubling was not completed until July 1870.

The GWR itself had built a broad-gauge line as an extension of the route from Westbury to Warminster. This line was served at Salisbury by a new station at Fisherton, which opened on 30 June 1856. The station buildings were designed by Isambard Brunel; this building has been subject to Grade II listing and is presently used by non-railway businesses. A small engine shed was built by the GWR in 1858 adjacent to their station; this was demolished in 1899 when the LSWR station was expanded and a new shed was built to the north of their line. This shed continued to be used until 1950, when the servicing facilities were transferred to the LSWR shed that had been built in 1901, although the building was not demolished until after 1956. As with Basingstoke, because the gauges differed, a connecting transhipment shed was built between the two stations. However, in 1874 the GWR broad-gauge line was converted to standard gauge, and later in 1878 a connection was built between the two railways that enabled freight wagons to be shunted between the two railways, therefore avoiding the need for goods to be transhipped. Nevertheless, it was not until 1896 that through services between the GWR station and LSWR destinations commenced. The GWR station continued to be used for services terminating at Salisbury until 12 December 1932, when all services began using the enlarged ex-LSWR station. However, the GWR station remained in situ, with the canopy not being removed until 1956; it is now part of the stabling and maintenance facilities for DMUs.

The LSWR Fisherton station was reached by an extension of the line from Basingstoke at Tunnel Junction through the 445-yard Fisherton Tunnel. The first LSWR station consisted of a single unidirectional platform with a bay at the London end, connected to the GWR station by a footbridge. This, plus the use of ticket platforms, caused delays to services, although a second platform devoted to London-bound services was not opened until the 1870s. This also had a bay at the London end. East of Fisherton Street and accessible from the street, the second platform was linked to the original platform via subway. Ticket platforms were very much used by the various railway companies; incoming trains were stopped there to enable tickets to be checked and collected before passengers alighted. With single-compartment coaches, this was a time-consuming process and it was not until the introduction of corridor coaches that the use of ticket platforms fell out of use. The LSWR station was enlarged between 1899 and 1902. This consisted of two new platforms between the original LSWR platform and the GWR station, serving three tracks. The 1870s platform was then closed. At the same time new station offices were built to the west of the original building. The 1859 building was not demolished and remains in situ, being used to house the Salisbury signal panel.

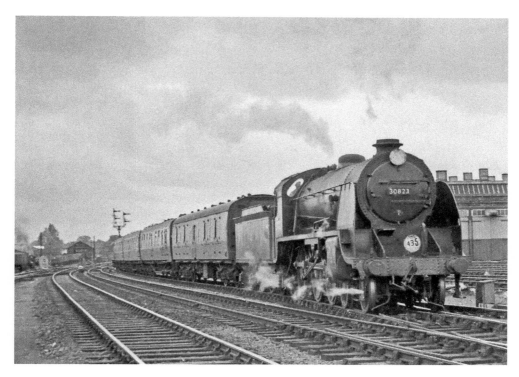

S15 Class No. 30823 approaches Salisbury with a stock working. The closed GWR shed is to the right, 21 June 1956.

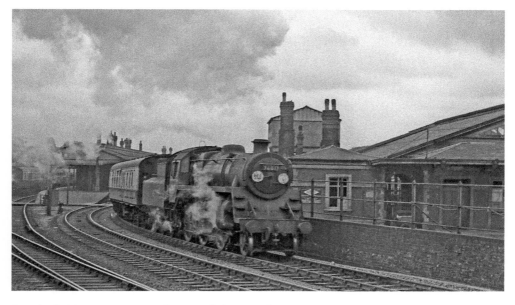

Standard 4 2-6-0 No. 76017 leaves Salisbury with a service to Portsmouth, 21 June 1956. The partly dismantled roof over the GWR platforms is at the top right.

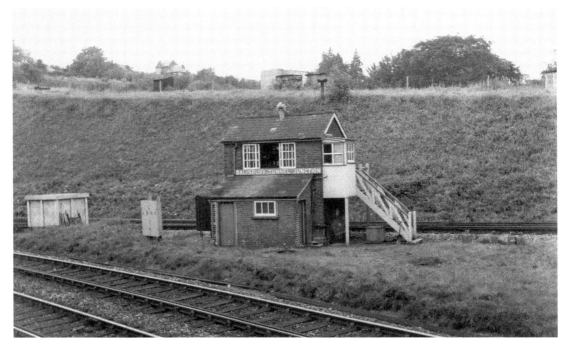

Tunnel Junction signal box, 9 October 1966. (John Scrase)

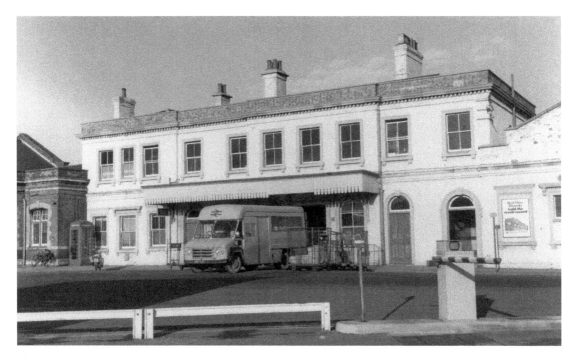

1859 Salisbury station building in use as a parcels depot, 6 December 1973. (John Scrase)

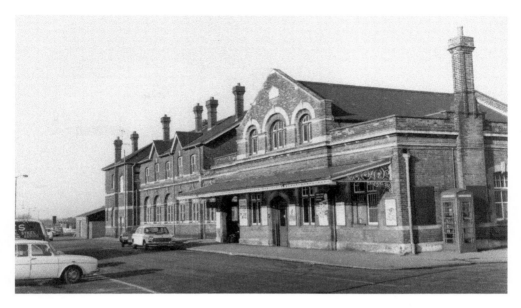

Salisbury station exterior, 6 December 1973. (John Scrase)

The eastern end of Salisbury station has a sharp ten-chain curve and, although it was the normal practice for passenger trains to stop at the station in any case, a 30-mph speed restriction was imposed. However, the weekly boat specials from Plymouth to Waterloo were booked to run non-stop, except for an engine change at Templecombe.

On the night of 30 June 1906, L12 Class 4-4-0 No. 421 took the train over at Templecombe. By the time it had reached Dinton, it was running 4 minutes late and ran past Salisbury West Box at some 60 mph. On the approach to the eastern end of the platform, No. 421 listed so much to its off-side that it struck an empty milk train travelling in the other direction; its tender was derailed and jack-knifed against the cab. All the coaches were either shattered or severely damaged, and a total of twenty-nine people lost their lives. Excessive speed was blamed by the LSWR as being the cause of the accident, although No. 421 was not the driver's regular engine and it is possible he was not fully aware of its higher centre of gravity when compared with his regular engine, T9 Class No. 283. Furthermore it is uncertain whether or not he had previously worked a non-stop service through Salisbury. As a direct result of this tragic accident, a 15-mph speed restriction was introduced, which is still in force, as well as a requirement for all through passenger services to stop at Salisbury. One of the features of train operations at Salisbury was the practice, other than for the Plymouth boat specials, for through services to and from Exeter to change engines. This was to enable the use of locomotives with smaller driving wheels more suitable to work over the inclines at Honiton. When the Lord Nelson class 4-6-0s were introduced on the West of England services, they were originally rostered to work through from Waterloo to Exeter Central.

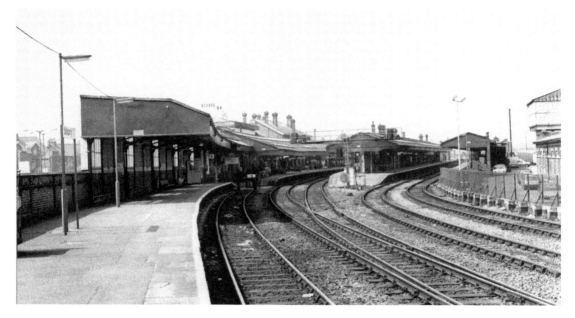

Salisbury platforms showing curvature, 5 May 1988. (John Scrase)

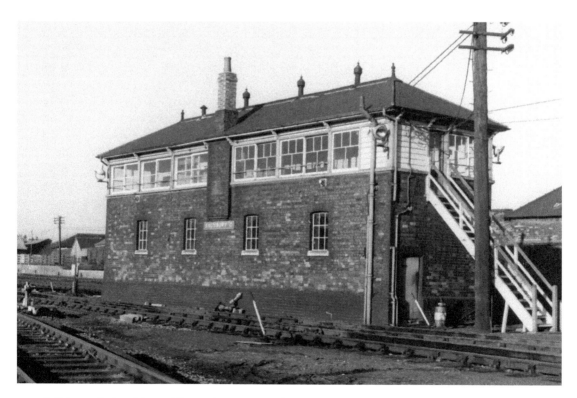

Salisbury C signal box, 6 December 1973. (John Scrase)

In practice, however, there was a need to take water at Salisbury, as water troughs were never used by the LSWR or Southern Railway. This caused delays to the services and engine changing was reinstated, with the Lord Nelsons working to and from Waterloo and normally a King Arthur Class 4-6-0 taking over. In some instances, some of the heavier trains would be double-headed with a King Arthur and a S15 4-6-0. With the advent of the Bulleid Pacifics through working from Waterloo to Exeter was reinstated; in fact, in 1962 there was a regular Saturday working from Waterloo to Exeter with a Schools Class 4-4-0.

There was a further, albeit short, railway line in Salisbury. This was the Salisbury Market House Railway. The original proposal was for a broad gauge but, since it ran from the LSWR side of Fisherton station, the LSWR insisted it was standard gauge. Always operated by the LSWR and its successors, and shown in the track diagrams as a siding, this line never became part of either the Southern Railway or British Railways, and eventually closed in 1964.

When the LSWR lines were extended to the station at Fisherton Street, the small engine shed at Milford was closed and replaced by a new one near the new station in 1859. Following the enlargement of the station, a new engine shed was opened on 12 January 1901. This shed continued to be used right up until the end of steam on the Southern Region. Used by the ex-GWR locos from 1950, it finally closed on 9 July 1967, being used in its latter years for the storage of withdrawn locomotives prior to their removal – in many cases, rather reluctantly and against their will, if the numbers taken off the trains en route are measured – to the various scrapyards in South Wales. In one instance M7 Class 0-4-4 tank No. 30667 spent some time at Swindon, possibly as a result of a 'hot box'. Thus ended the reign of steam at Salisbury.

The reduced use of steam through Salisbury had commenced much earlier in 1964, when route rationalisation led to the GWR line from Paddington to Exeter being deemed to be the principal route to the West Country, with the old LSWR line reduced to secondary status. Paddington and Swindon had got their way at last! In 1967 the route west of Wilton was converted to single-line tokenless block working, with passing and crossing points at the other stations. By September all services from Waterloo were being worked by Warship diesel-electric Bo-Bos, with the last steam-hauled Atlantic Coast Express running on 4 September 1964. The use of diesel traction on the Waterloo–Exeter services was not new, however, as between 1951 and 1955 the three prototype Southern 1Co-Co1s Nos 10201, 10202 and 10203 worked many of these services, followed by the two LMS Co-Cos Nos 10000 and 10001. The Warships had reliability problems at times and on occasion Hymec Bo-Bos were used west of Salisbury. Salisbury men were familiar with this type since for several years they had been used earlier on the Cardiff–Portsmouth inter-regional services. It was not unknown for Western Co-Co diesel-hydraulic and D63xx diesel-hydraulic Bo-Bos to also cover for failures. With the commencement of the October 1971 winter timetable, the Warships, not having diesel-electric transmission, were displaced by Eastleigh-based Class 33s, the Cromptons, hauling Southern EMUs. Even so, the Warships, now known as

Salisbury shed with withdrawn locos. (Jeffrey Gayer)

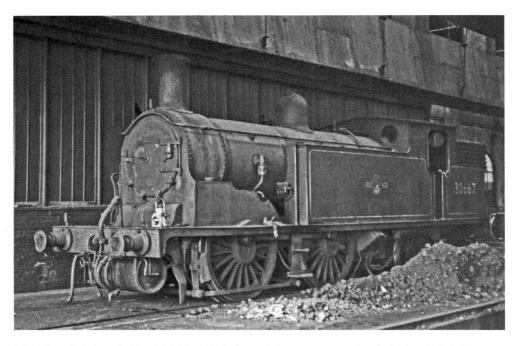

M7 Class 0-4-4 tank No. 30667 at Swindon while en route to South Wales. (Mick Hymans collection – date not known)

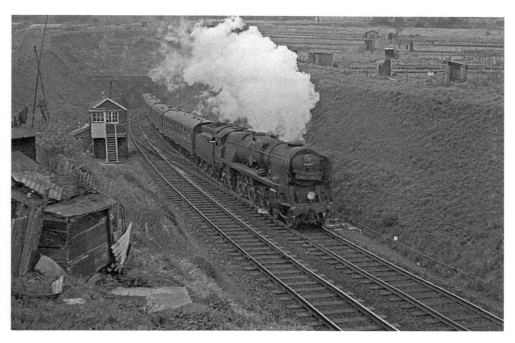

Merchant Navy Class No. 35013 *Blue Funnel* passes Tunnel Junction signal box with the Up Atlantic Coast Express, 18 July 1964. (Edwin Wilmshurst)

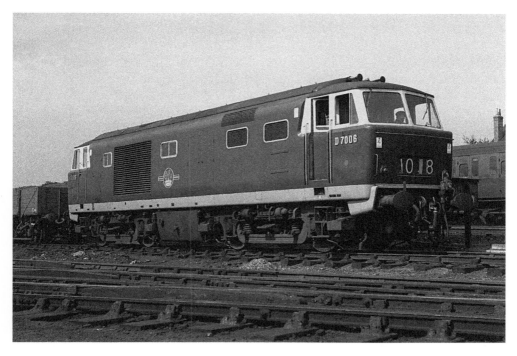

Hymec Bo-Bo diesel-hydraulic D7006 at Salisbury shed, 2 September 1962.

Class 42s, struggled on for another fifteen months, usually on stone workings from the Mendips. A service of particular interest was the through working from Brighton to Plymouth, which, after the closure of the LSWR route via Okehampton, was hauled by two Hither Green-based Cromptons as far as Exeter. In the winter of 1971/72, this became a Saturday-only service, starting from Salisbury using a Western region DEMU. In May 1972 a Saturday-only service was restored from Brighton using spare Hastings DEMU units. In May 1980 there was yet another change with the introduction of Class 50 Co-Co diesel-electrics that had been made redundant by the introduction of HST sets on the Western Region's InterCity services. The displaced Cromptons took over the Portsmouth–Bristol services previously worked by unreliable Class 31 A1A-A1A diesels. By 1990 the poor availability of the Class 50s meant Class 47 Co-Co diesels started to be introduced on the Waterloo services. However, this still did not solve the motive power problems, and this was solved by the introduction of Class 158 and 159 multiple units, the last use of Class 50s being in January 1992. The gradual introduction of the Class 158 and 159s resulted in Class 33 and Class 47 usage finishing in June 1993. Nowadays, the passenger services using Salisbury are served by Class 150, Class 153, Class 158 and Class 159 multiple units. Freight services, mainly stone trains from the Mendips, are invariably hauled by the ubiquitous Class 66 Co-Cos.

The cathedral city of Salisbury can trace its origins back to somewhere between 600 and 300 BC with the development of a hill fort at *Sovlodunum*, situated north of the present city at the site, now named Old Sarum. This fort served as a market in times of peace and as a stronghold in times of strife, right through the times of the Romans and up to the arrival of the Saxons. However, in Saxon times it was more or less abandoned until it was refortified during Viking invasions, now being known as *Searoburh*. By 1070 a motte-and-bailey castle had been erected and, now named Salisbury, it had become the seat of the sees of Sherborne and Ramsbury with cathedral precincts within the castle walls. However, after the death of Bishop Roger of Caen in 1139, the clergy, who were in dispute with the civilian authorities, felt it desirable to relocate the cathedral and the present site was chosen. The cathedral's foundation took place during April 1220, with final completion being in March 1266. In the meantime the town was rapidly growing and, by the start of the sixteenth century, Salisbury had become one of the largest cities in England, although it was much under the authority of the Church, with much of the city's wealth being in the wool trade and, even in those times, tourism. By the nineteenth century the city's prosperity was in decline with the loss of overseas markets, while the gradual mechanisation on the land and the Corn Laws caused distress and discontent among the agrarian workforce. However, in the 1830s matters gradually improved following a series of political and social reforms and the improvement of farm wages.

The coming of the railways from 1847 meant the journey time between Salisbury and London had been considerably reduced, and excursion trains started to run. The further expansion westwards sounded a death knell for horse-drawn coach operation, the last journey to London being in 1846. These improvements in communication

further strengthened Salisbury's position as a centre for trade and tourism. Major industries include lace production, leather, brewing and clock making.

By 1900 Salisbury continued to grow, and in 1902 a venture was formed between Percy Dean, a farmer's son, and the Burden brothers, who were clockmakers, to make engines for motorboats, motorcycles and motorcars. This culminated in the company being renamed Scout Motors, producing cars, delivery vans and, later, omnibuses. While production was not high, the company was reasonably successful; nevertheless, the mass production of cheaper cars, notably by William Morris and Henry Ford, spelt the death knell of many small car manufacturers and Scout Motors went into liquidation in 1921. It is thought that probably two of the Scout cars remain in existence. In some respects Salisbury has continued to be a centre of niche industry, with motor tuning and hi-fi production being just two examples. Of special mention is the Edgley Optica observation aircraft. This was of a very distinctive design, with the cabin having 270-degree vision, looking rather like a large dragonfly. Production commenced at the airfield at Old Sarum, but disaster struck on the night of 17 January 1987 when an arson attack destroyed all but one of the completed aircraft. Although the company changed hands several times after that event, production never restarted; one aircraft has been restored to flying condition.

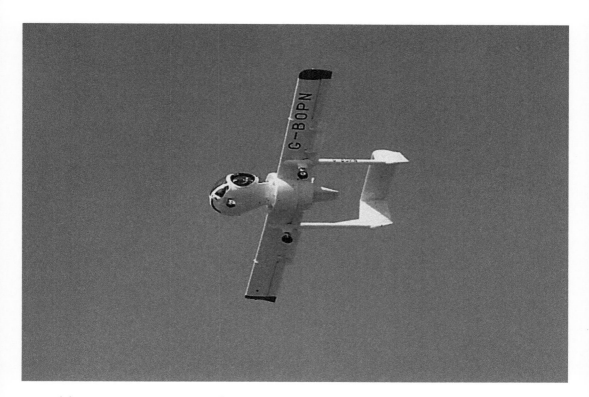

Edgley Optima G-BOPN at Farnborough. (John Evans)

The 2011 census gave the population as being just over 40,000. With its cathedral, Salisbury continues to be a tourist centre, with visitors not only visiting the cathedral but other notable nearby properties including the home of former Prime Minister Sir Edward Heath. In 2011 the city's museum staged an exhibition of the works of the painter John Constable, who was associated with the city due to his patronage by John Fisher, the Bishop of Salisbury.

My first visit to Salisbury was on 21 June 1956; of course, later in the day I was at Basingstoke. I am not sure on which service I travelled down from Waterloo, but the first photograph I took was of the first rebuilt Merchant Navy, No. 35018 *British India Line,* departing with the Down Atlantic Coast Express. The Bulleid Pacifics in their original form were plagued with a number of problems and, by 1955, serious consideration was given to their withdrawal. However the anticipated long life of their fireboxes in particular led to the decision to rebuild them as conventional

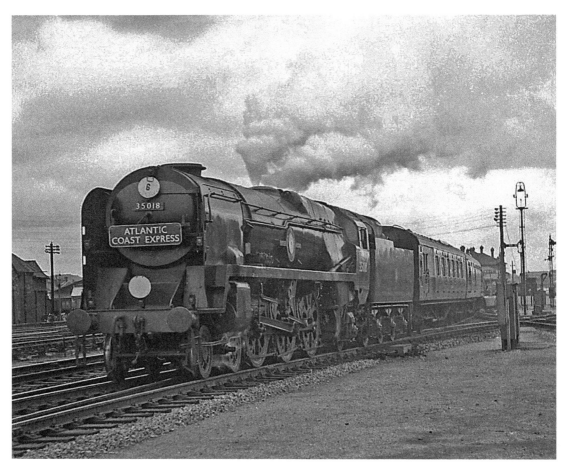

Rebuilt Merchant Navy Class No. 35018 *British India Line* leaving Salisbury with the Down Atlantic Coast Express, 21 June 1956.

locomotives, therefore producing what were arguably to become some of the finest express steam locomotives in Britain. Since I regularly received *The Railway Magazine* when I was in Germany, albeit several weeks after publication, I knew the first rebuild had taken place but was unaware that No. 35018 had re-entered service and so it was not something I expected to see. Making my way toward the engine shed I saw GWR 2251 Class 0-6-0 No. 2268 on a freight from Westbury. On shed and waiting to work a service to Waterloo was Maunsell King Arthur Class 4-6-0 No. 30449 *Sir Torre*. No. 30449 was a member of the first series of N15s that Maunsell developed from the earlier Urie LSWR locomotives, and differed from the later series by having Drummond style eight-wheeled 'cartwheel' tenders with inside bearing and LSWR cabs. Alongside No. 30449 the GWR dynamometer coach can be seen. Another Maunsell loco on shed, having worked a service from London, was Lord Nelson Class 4-6-0 No. 30854 *Howard of Effingham*. Most of the passenger services to and from the Western Region via Westbury were usually worked by Hall or Grange Class locomotives, but there were occasional turns for the County Class 4-6-0s. They had slightly larger driving wheels than the other GWR mixed-traffic engines and also a long splasher over the driving wheels, which meant that the nameplates were straight rather than curved. No. 1009 *County of Carmarthen* was awaiting its next duty. Continuing round the engine sheds I found out why the dynamometer coach was there – for, being prepared for a test run was

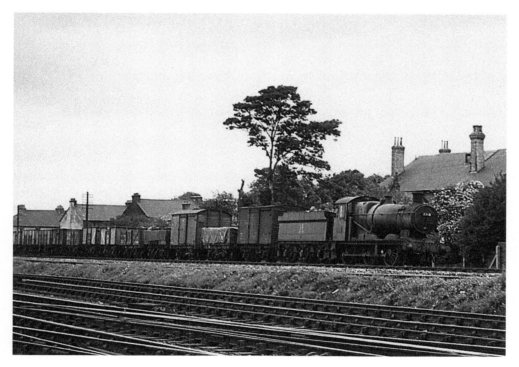

GWR 2251 Class 0-6-0 No. 2268 entering Salisbury with a freight from Westbury, 21 June 1956.

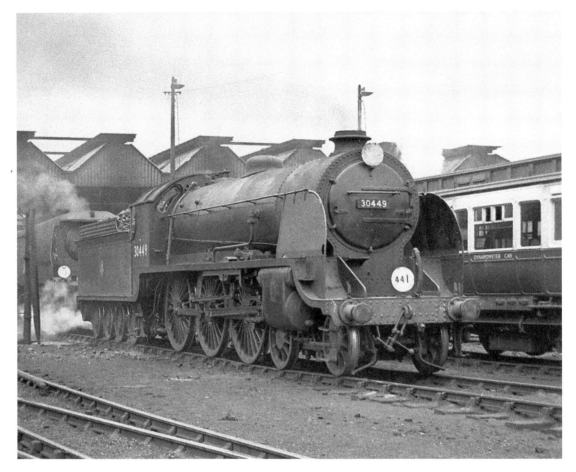

King Arthur Class No. 30449 *Sir Torre*. Salisbury shed, 21 June 1956.

the second of the Merchant Navy rebuilds, No. 35020 *Bibby Line*. The rebuilding at Eastleigh of No. 35020 did not commence until the end of May, so it could not have long been out of Eastleigh Works when I saw it; to have seen both of these rebuilds on the same day was an unexpected bonus for this serviceman on leave from Germany! I was, later in the day, to photograph No. 35030, complete with test train standing in the sidings alongside Salisbury East signal box. Returning toward the station, Maunsell S15 No. 30845 was photographed arriving on an Up slow train from Exeter. The next train photographed was the 09.30 Brighton–Plymouth service, which had just been taken over by West Country Class 4-6-2 No. 34037 *Clovelly*. The final Up service I saw was the Atlantic Coast Express, headed by Merchant Navy Class No. 35024 *East Asiatic Company*; the external difference between this locomotive and the rebuilds is most striking. The final photograph taken at Salisbury was of Urie H15 Class 4-6-0 No. 30332 trundling through the station with a Down goods train at the sharp curve that resulted in the 1906

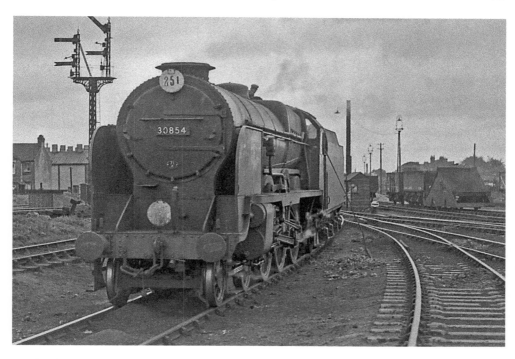

Lord Nelson Class No. 30854 *Howard of Effingham*, Salisbury shed, 21 June 1956.

County Class No. 1009 *County of Carmarthen*, Salisbury shed, 21 June 1956.

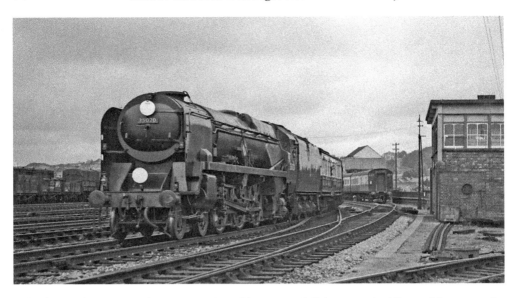

Rebuilt Merchant Navy Class No. 35020 *Bibby Line* at Salisbury north sidings with a test train, 21 June 1956.

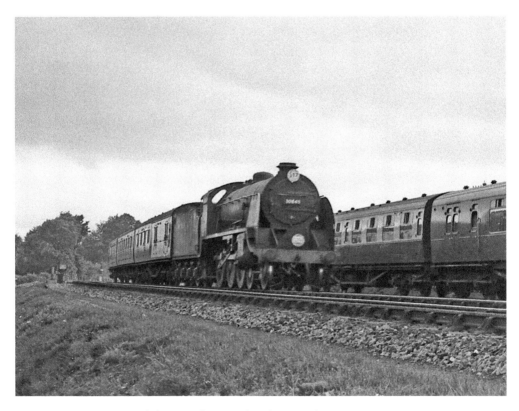

S15 No. 30845 enters Salisbury with an Up local service from Exeter, 21 June 1956.

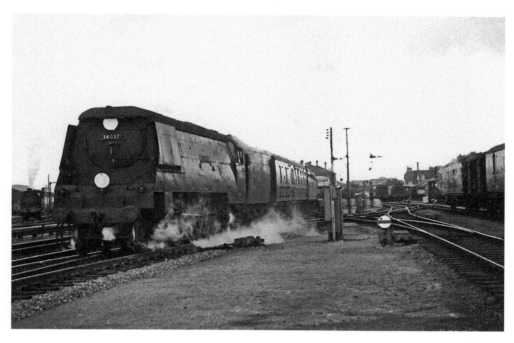

West Country Class No. 34037 *Clovelly* leaves Salisbury with the 09.30 Brighton–Plymouth service, 21 June 1956.

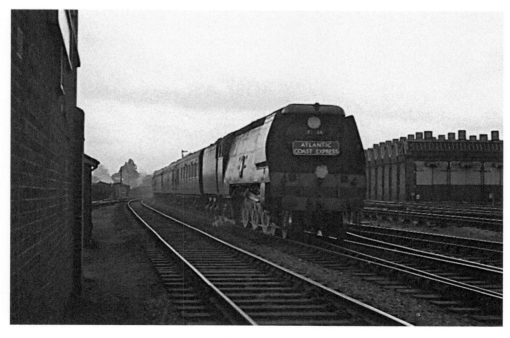

Merchant Navy Class No. 35024 *East Asiatic Company* enters Salisbury with the Up Atlantic Coast Express, 21 June 1956. The former GWR engine shed can be seen to the right.

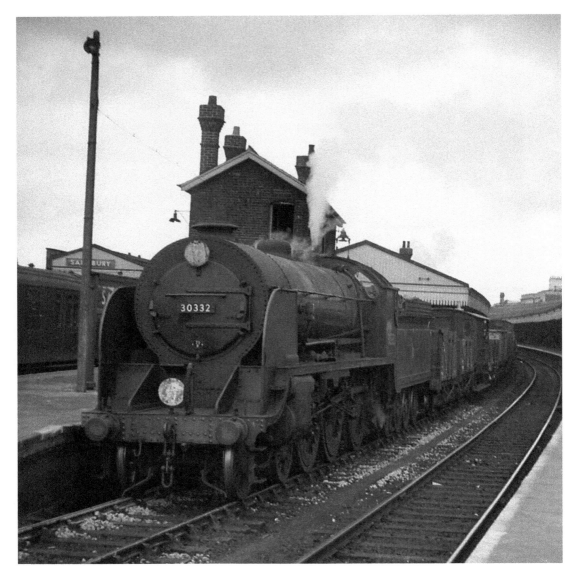

H15 Class No. 30332 at Salisbury station with a Down freight, 21 June 1956.

high-speed derailment. This locomotive itself is interesting, being originally one of Dougal Drummond's early four-cylinder 4-6-0s of Class F13, the performance of which left much to be desired. In 1924 it was nominally rebuilt as a two-cylinder locomotive, although the only parts of the original locomotive used were the boiler shell, tender and bogie wheels. Later in the day, of course, I went to Basingstoke.

The next time I was to visit Salisbury was on 25 November 1961, when I came down from London on the 09.00 service from Waterloo to the West of England. This service was hauled by rebuilt West Country Class 4-6-2 No. 34050

Royal Observer Corps, seen here departing for Exeter. The next Down departure was the 11.04 to Yeovil, headed by Standard 4 2-6-0 No. 76067. Many of the freight services in the Salisbury area were worked by S15 4-6-0s, both the Maunsell and Urie varieties. Two were seen working freights west of the station: No. 30845 is seen approaching with the 21.25 from Plymouth, whereas No. 30499 is waiting set back with the 03.00 from Brighton. To the left the entrance to Salisbury engine sheds can be seen. GWR Hall Class 4-6-0s were used on many of the inter-regional trains in and out of Salisbury; No. 6936 *Breccles Hall* had taken over the 09.30 Portsmouth–Cardiff service, while later in the day No. 6932 *Burwarton Hall* was to work the 11.00 Brighton–Cardiff service. There were also several freight workings from the Western Region. An early arrival during my visit was Churchward Class 4700 2-8-0 No. 4702, a welcome sight indeed. On what I believe to have been the 04.12 freight service from Cardiff was 2251 Class 0-6-0 No. 3212, and working the 02.35 freight train from Radyr was 2884 Class 2-8-0 No. 3850. Near to the same location as 3850, County Class 4-6-0 No. 1011 *County of Chester* was seen approaching with the 10.55 passenger service. Later, it would appear that the duties in the Salisbury area usually undertaken by County class locos would be hauled by Hymec diesel-hydraulics, an example of which was D7004 on

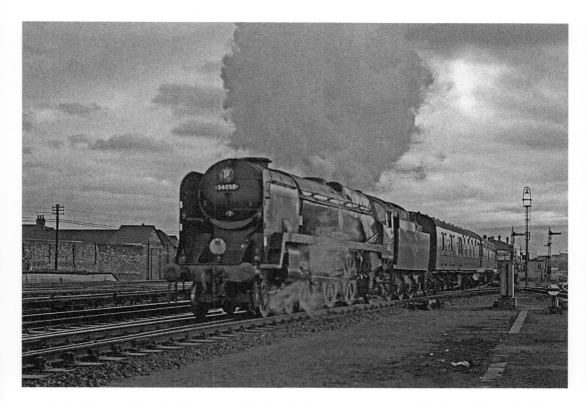

Rebuilt Battle of Britain Class No. 34050 *Royal Observer Corps* leaves Salisbury with the 09.00 Waterloo–the West of England service, 25 November 1961.

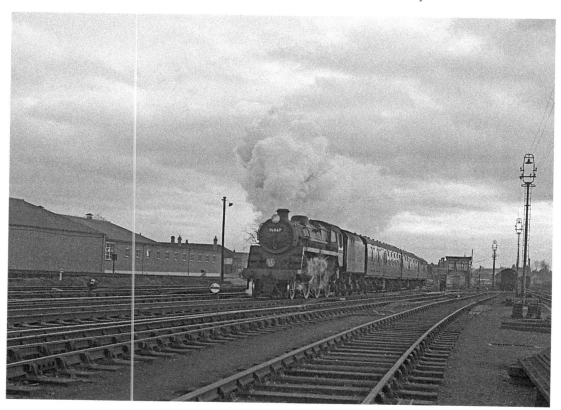

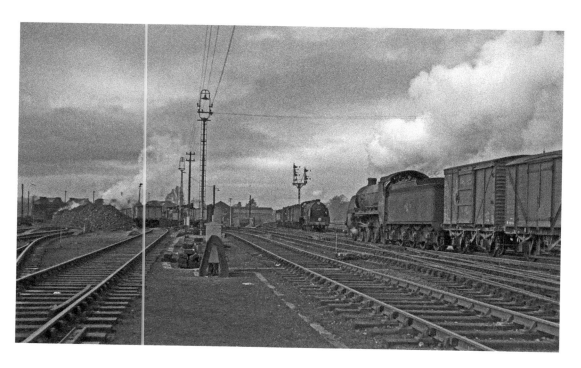

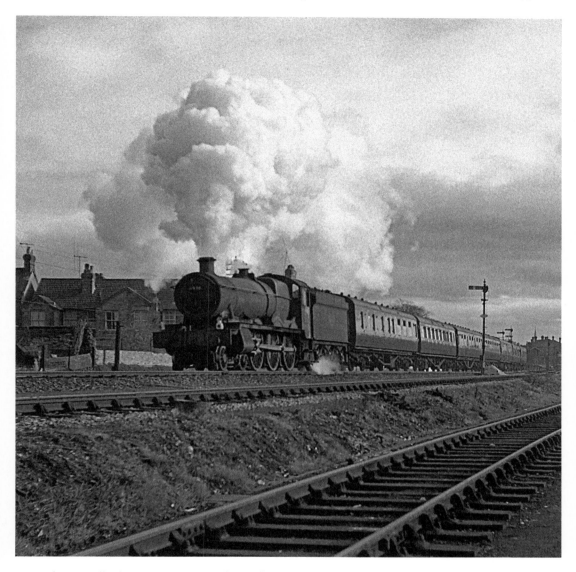

Above: Hall Class No. 6936 *Breccles Hall* leaves Salibury with the 09.30 Portsmouth–Cardiff service, 25 November 1961.

Opposite above: Standard 4 2-6-0 No. 76067 leaves Salisbury with the 11.04 service to Yeovil, 25 November 1961.

Opposite below: S15 Class Nos 30845 and 30499 on freight services, west of Salisbury station on 25 November 1961.

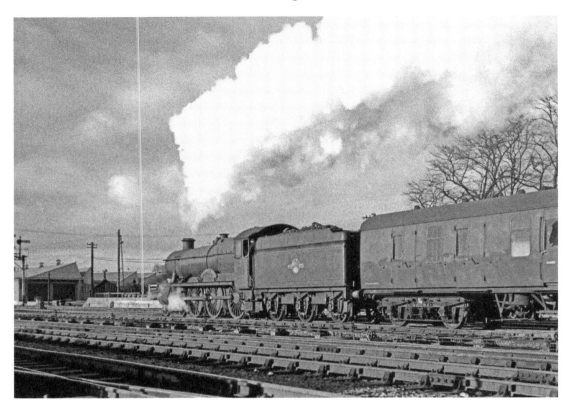

Above: Hall Class No. 6932 *Burwarton Hall* leaves Salisbury with the 11.00 Brighton–Cardiff service, 25 November 1961.

Opposite above: 4700 Class No. 4702 approaches Salisbury with a Western Region freight on 25 November 1961.

Opposite below: 2251 Class No. 3212 approaching Salisbury with the 04.12 freight from Cardiff, 25 November 1961.

the 12.18 to Bristol. After taking the photograph of No. 1011, I continued westward on the Southern lines towards Wilton to photograph Merchant Navy Class 4-6-2 No. 35029 *Ellerman Lines* on the Down Atlantic Coast Express. Closer to Salisbury, in indifferent light, rebuilt Battle of Britain class No. 34058 *Sir Frederick Pile* headed the short 06.15 passenger service from Plymouth; the Western Region lines can be seen just to the right of the photograph. Returning to the station area, a clean M7 Class, No. 30021, was on piloting duties, having recently transferred from Exmouth Junction. Waiting to depart with the 13.05 freight train to Templecombe was the rebuilt Battle of Britain 4-6-2 No. 34052 *Lord Downing*. The final photograph taken that day was BR Standard 4 2-6-0 No. 76066, leaving the station with the 10.30 Cardiff–Portsmouth service.

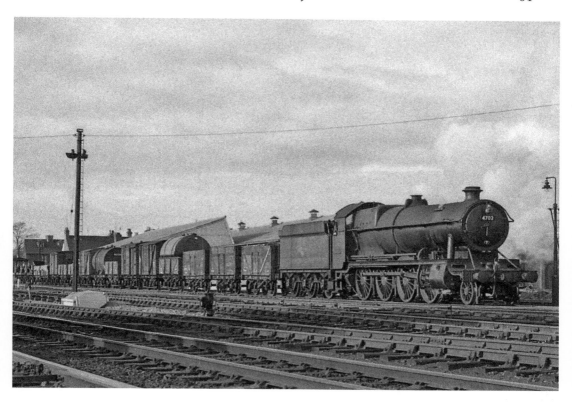

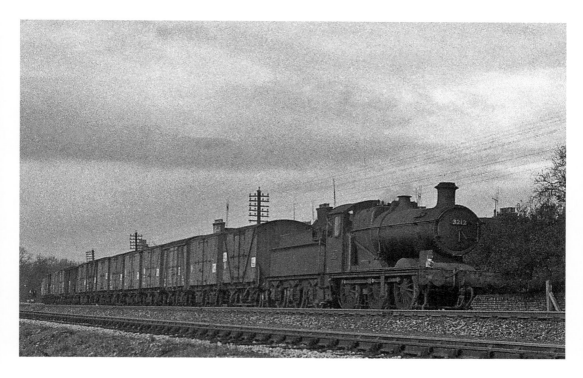

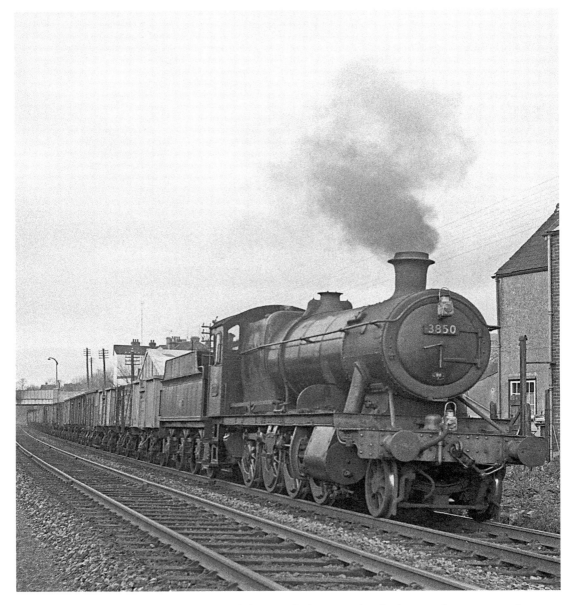

Above: 2884 Class No. 3850 near Salisbury with the 02.35 freight from Radyr, 25 November 1961.

Opposite above: County Class No. 1010 *County of Chester* is near Salisbury with the 10.55 service from Bristol, 25 November 1961.

Opposite below: Hymec D7004 leaves Salisbury with the 12.18 to Bristol, 25 November 1961.

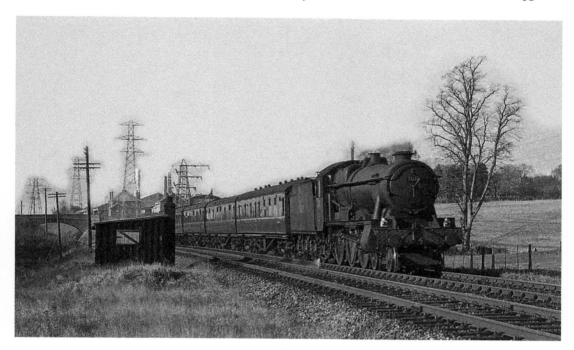

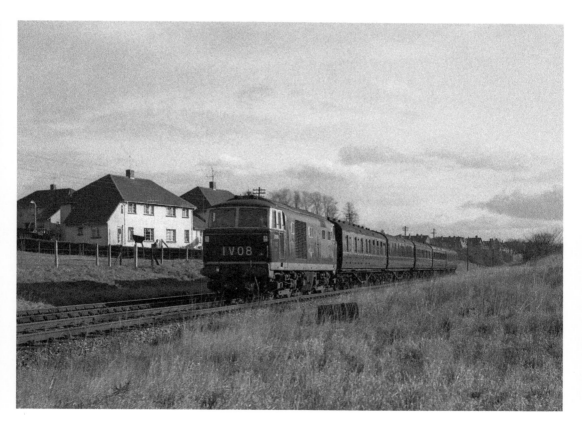

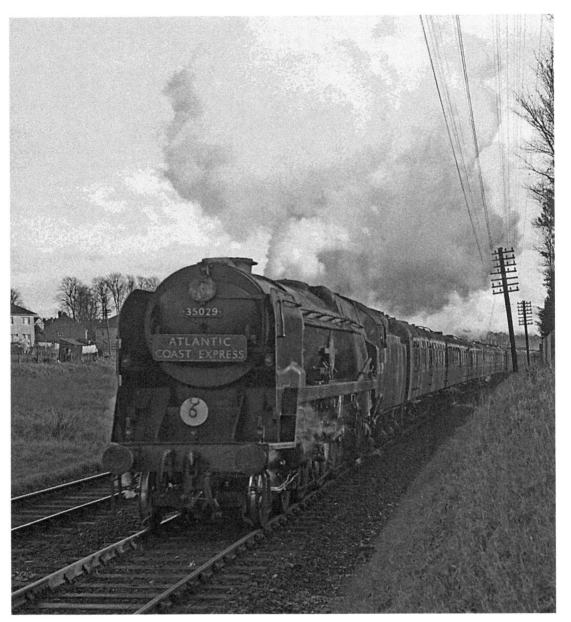

Above: Merchant Navy Class No. 35029 *Ellerman Lines* is near Wilton with the Down Atlantic Coast Express, 25 November 1961.

Opposite above: Rebuilt Battle of Britain Class No. 34058 *Sir Frederick Pile* near Salisbury with the 06.15 service from Plymouth, 25 November 1961.

Opposite below: M7 Class No. 30021 on piloting duties, 25 November 1961.

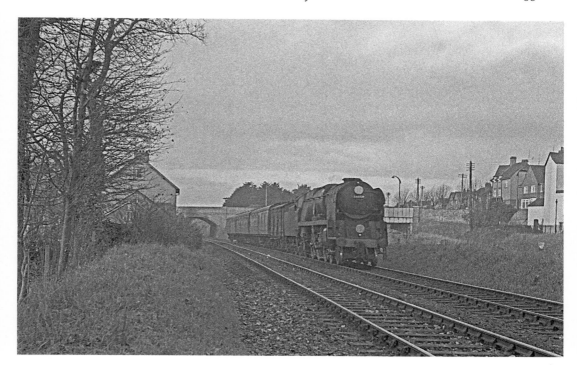

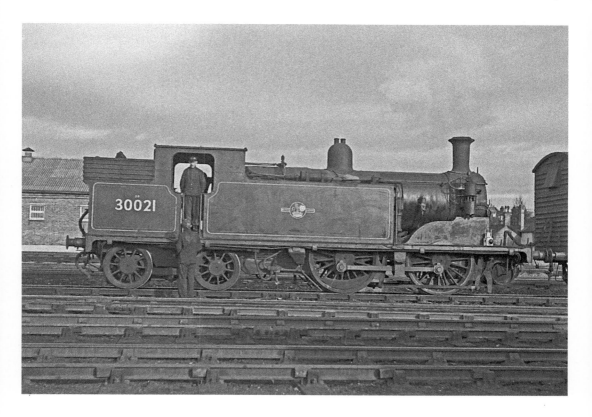

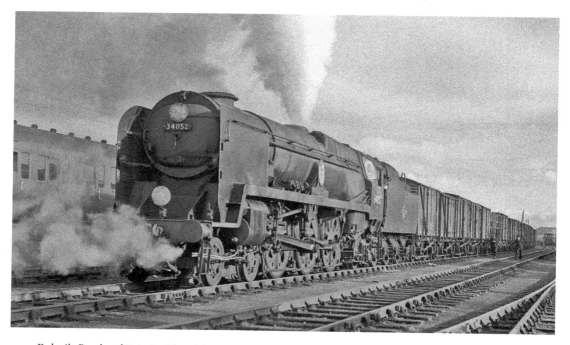

Rebuilt Battle of Britain Class No. 34052 *Lord Downing* departs with the 13.05 freight service to Templecombe, 25 November 1961.

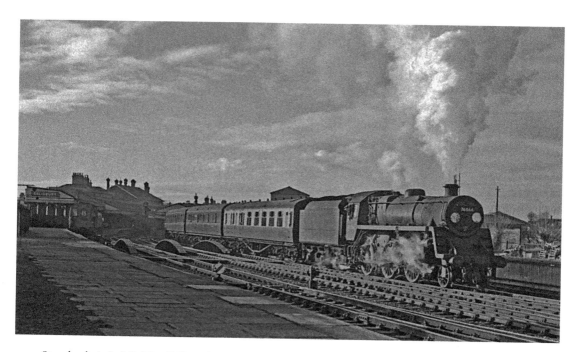

Standard 4 2-6-0 No. 76066 leaves Salisbury with the 10.30 Cardiff–Portsmouth service, 25 November 1961.

I was again at Salisbury on 21 April 1962, travelling down again on the 09.00 service from Waterloo, this time hauled by Merchant Navy Pacific No. 35025 *Brocklebank Line*. This visit was to prove to be problematic from a photographic point of view, as the light was not that good and I was also using a camera that had been lent to me, with which I was not familiar. Before I could record the departure of No. 35025, a freight approached from the Westbury direction, headed by Grange Class 4-6-0 No. 6847 *Tidmarsh Grange*. Following the departure of the 09.00 service from Waterloo was Standard 4 2-6-0 No. 76067 on the 11.04 service to Yeovil. The next arrival was the 21.25 freight from Plymouth, again under the control of a Maunsell S15 – this time No. 30845. This was one of those instances wherein my photographic efforts were unsuccessful.

As on previous visits there were several inter-regional trains to be seen. A departure for which I have no details was headed by Hall Class No. 6944 *Fledborough Hall*. I then decided to start walking to the west alongside the twin tracks; the first service seen was the 09.30 Parsons Street–Bournemouth service, hauled by Hall Class No. 4949 *Packwood Hall*. On the Southern tracks, rebuilt West Country 4-6-2 No. 34096 *Trevose* approached with the 06.15 service from Plymouth. The spot I had reached proved to be good for seeing trains on the rival Western and Southern routes to the west. 2251 Class 0-6-0 No. 3212 was again seen on the 04.17 freight from Cardiff, and rebuilt Battle of Britain Class

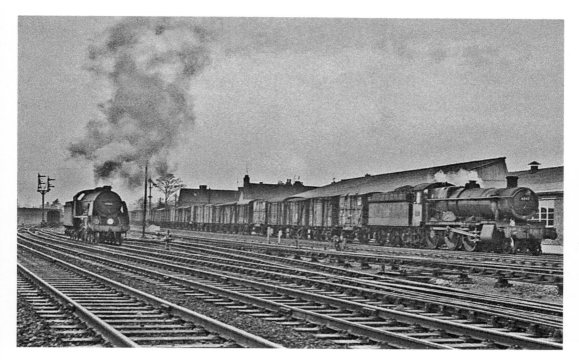

Grange Class 4-6-0 No. 6847 *Tidmarsh Hall* enters Salisbury with a freight service on 21 April 1962.

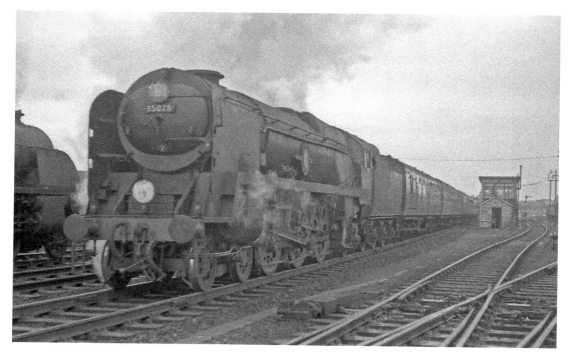

Merchant Navy Class No. 35025 *Brocklebank Line* leaves Salisbury with the 09.00 Waterloo–the West of England on 21 April 1962.

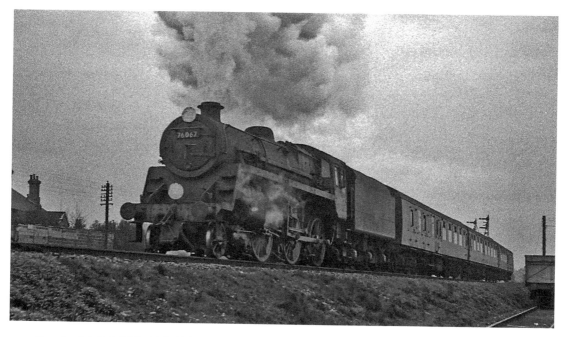

Standard 4 2-6-0 No. 76067 leaves Salisbury with the 11.04 service to Yeovil, 21 April 1962.

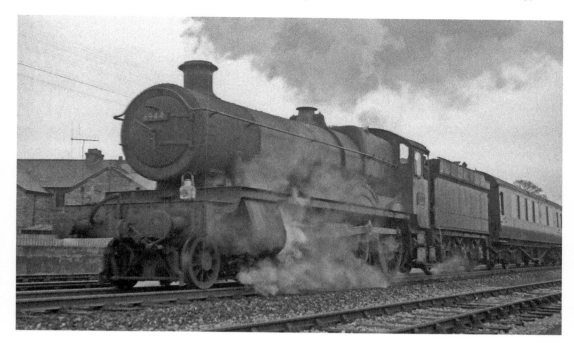

Hall Class No. 6944 *Fledborough Hall* leaves Salisbury with an inter-regional service on 21 April 1962.

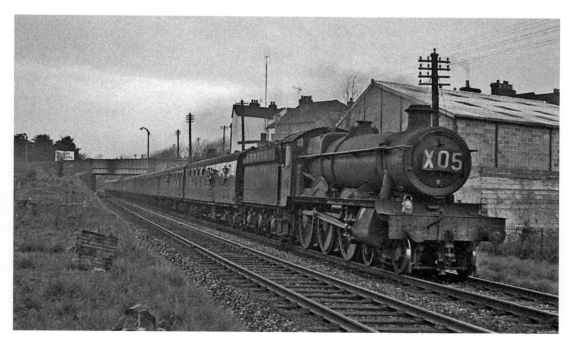

Hall Class No. 4949 *Packwood Hall* nears Salisbury with the 10.30 service from Parsons Street to Bournemouth, 21 April 1962.

No. 34062 *17 Squadron* worked the 08.25 Plymouth–Waterloo service. I did not see any County Class 4-6-0s on this trip, which was one of their normal types of duties; the 12.16 service from Salisbury to Bristol was instead hauled by Hymec diesel-hydraulic D7014. In the reverse direction, the 10.55 Bristol–Portsmouth service had Hall Class No. 5989 *Cransley Hall* working it. Moving slightly further west toward Dinton, I managed to photograph the original Merchant Navy Class locomotive No. 35001 *Channel Packet* on the Down Atlantic Coast Express, followed by rebuilt Battle of Britain Class No. 34050 *Lord Downing* with the 12.36 service to Exeter. Returning towards the station, an interesting sight was Collett 7200 Class 2-8-2 tank No. 7205 on a freight, possibly the 02.35 from Radyr, a service previously seen by me being hauled by a 2884 Class 2-8-0, both locos being based at Aberdare. Another freight working from the Western Region was headed by Standard 9 2-10-0 No. 92205. Having arrived back in the vicinity of Salisbury engine sheds, No. 34096 *Trevose* had been turned and was being prepared ready for a return trip to Exeter. Just leaving afterwards with the 13.05 freight to Templecombe was rebuilt West Country No. 34048 *Crediton*. Returning to the station, Standard 4 2-6-0 No. 76054 was simmering away; I had first seen this locomotive in 1955 when it was brand new and at Redhill for trials over the route to Reading via Guildford.

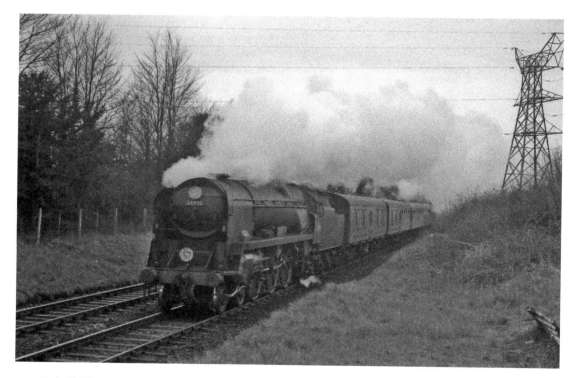

Rebuilt West Country No. 34096 *Trevose* near Salisbury with the 06.15 service from Plymouth, 21 April 1962.

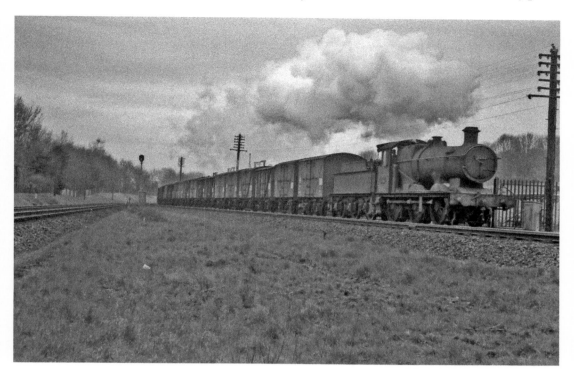

Class 2251 0-6-0 No. 3212 on the 04.17 freight from Cardiff, 21 April 1962.

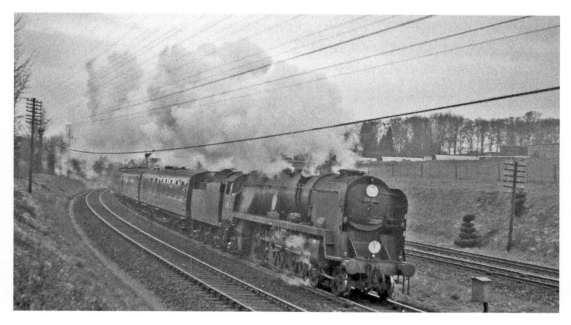

Rebuilt Battle of Britain Class No. 34062 *17 Squadron* is west of Salisbury with the 08.25 Plymouth–Waterloo service, 21 April 1962.

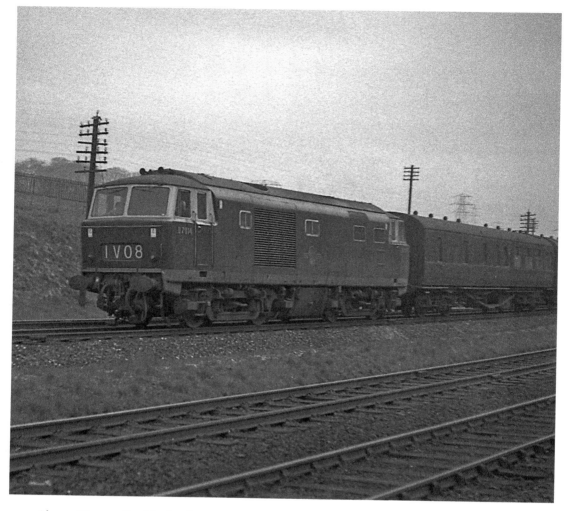

Above: Hymec diesel-hydraulic D7014 leaves Salisbury with the 12.15 service to Bristol on 21 April 1962.

Opposite above: Hall Class No. 5989 *Cransley Hall* approaches Salisbury with the 10.55 Bristol–Portsmouth, 21 April 1962.

Opposite below: Merchant Navy Class No. 35001 *Channel Packet* is west of Salisbury with the Down Atlantic Coast Express, 21 April 1962.

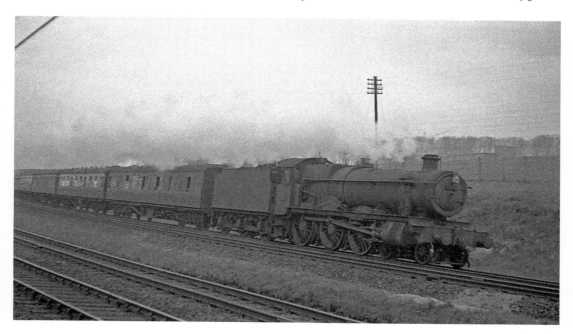

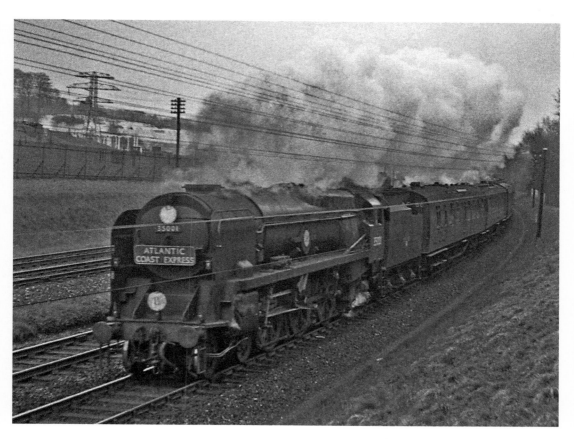

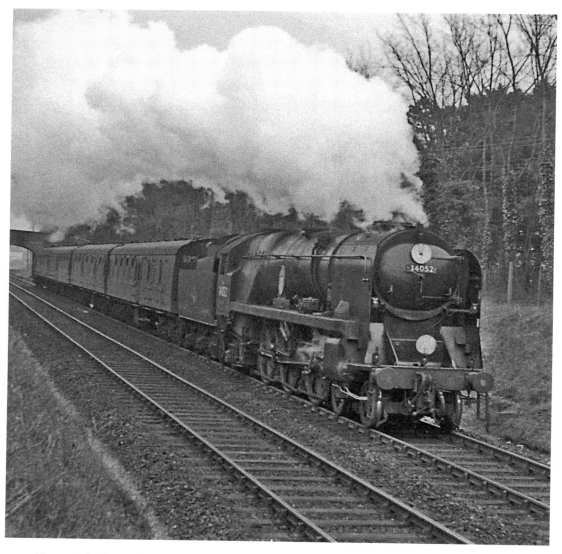

Above: Rebuilt Battle of Britain No. 34052 *Lord Downing* west of Salisbury with the 12.36 service to Exeter on 21 April 1962.

Opposite above: 7200 Class 2-8-2 tank No. 7205 approaches Salisbury with a freight train on 21 April 1962.

Opposite below: Standard 9 2-10-0 No. 92205 near Salisbury with a freight train on 21 April 1962.

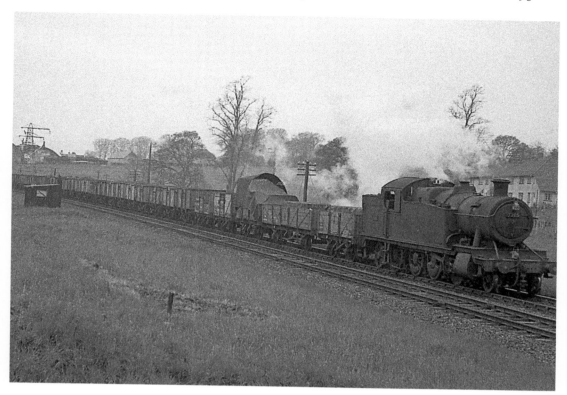

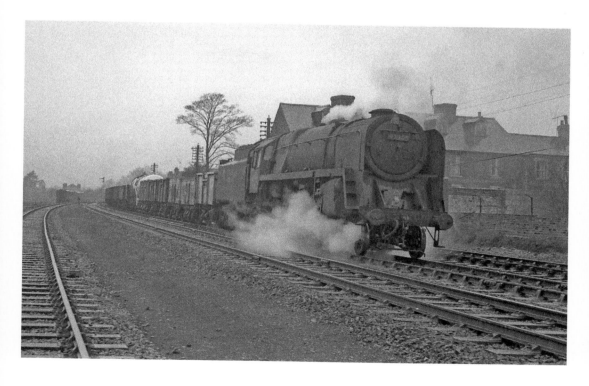

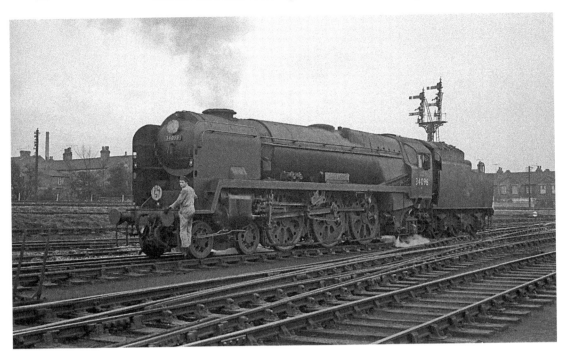

Rebuilt West Country No. 34096 *Trevose* at Salisbury shed, 21 April 1962.

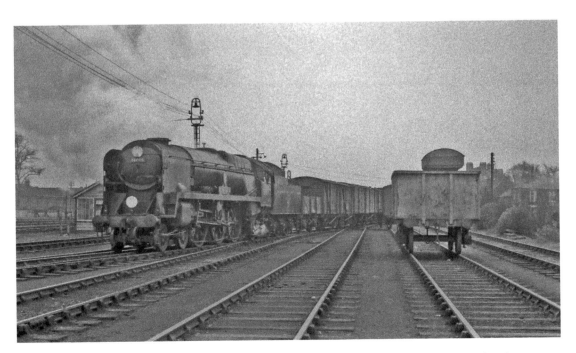

Rebuilt West Country No. 34048 *Crediton* leaves Salisbury with the 13.05 freight to Templecombe, 21 April 1962.

Unusually for me, I then walked along the trackside in the London direction in time to photograph Rebuilt West Country No. 34027 *Taw Valley*, which had just exited Fisherton Tunnel with the Brighton–Cardiff through service. The final photograph taken that day was of Merchant Navy Class No. 35024 *East Asiatic Company* arriving with the Up Atlantic Coast Express; it is more than possible that I returned to London on that service.

I was not to visit Salisbury again until 2 September 1962, the last Sunday of the 1962 summer service. Being a Sunday, movements were fewer than on a Saturday. Nonetheless, it was pleasing to see Schools Class No. 30925 *Cheltenham*, fresh from its fast run to Exeter the previous day, arriving with the 08.35 Plymouth–Waterloo service. Unlike earlier visits, I spent some time at the engine sheds seeing another Schools Class, No. 30935 *Sevenoaks*. As with others of the class, these two locomotives were part of the cull of Southern engines in December 1962, irrespective of their mechanical condition; fortunately, *Cheltenham* has survived to become part of the National Collection. Alongside *Sevenoaks* was Q1 Class 0-6-0 No. 33010. Also on shed were Merchant Navy No. 35022 *Holland America Line* and BR Standard 5 4-6-0 No. 73081 *Excalibur*. As previously stated, passenger movements were few and far between. However, they included the 10.30 Brighton–Plymouth service, seen leaving behind rebuilt West Country Class No. 34014 *Budleigh Salterton*, and the 10.30 Ilfracombe–Waterloo service headed by West Country Class No. 34091 *Weymouth*, the sharp curvature of the platforms being very evident. After taking these photographs I returned home, this being my final visit to Salisbury.

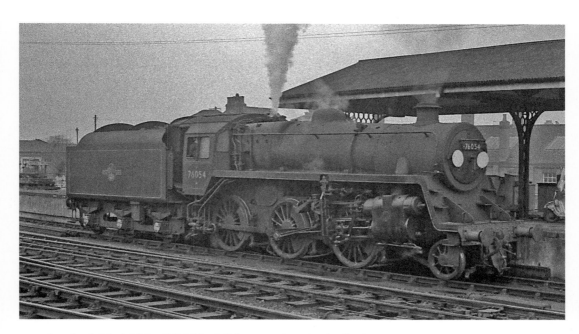

Standard 4 2-6-0 No. 76054 in Salisbury station, 21 April 1962.

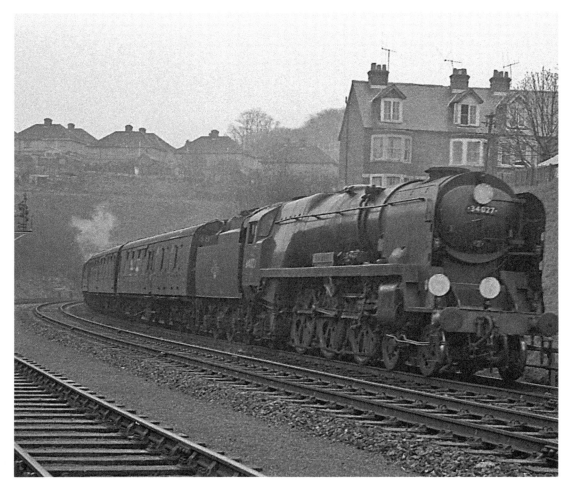

Above: Rebuilt West Country No. 34027 *Taw Valley* exits Fisherton Tunnel with the Brighton–Cardiff service on 21 April 1962.

Opposite above: Merchant Navy Class No. 35024 *East Asiatic Company* enters Salisbury with the Up Atlantic Coast Express, 21 April 1962.

Opposite below: Schools Class No. 30925 *Cheltenham* enters Salisbury with the 08.35 Plymouth–Waterloo service on 2 September 1962.

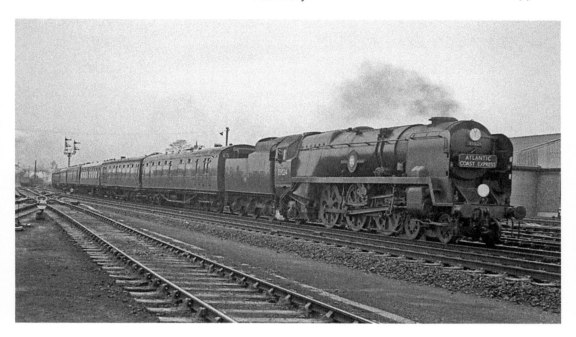

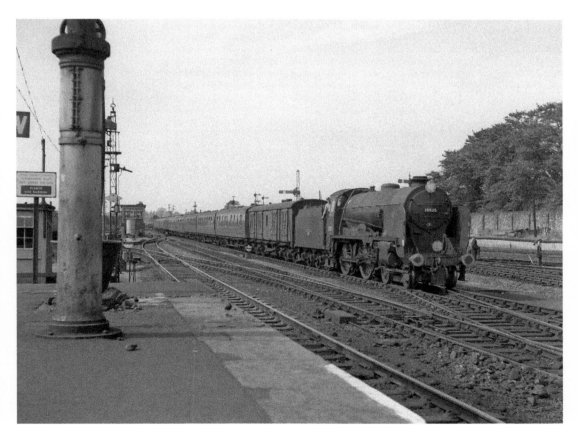

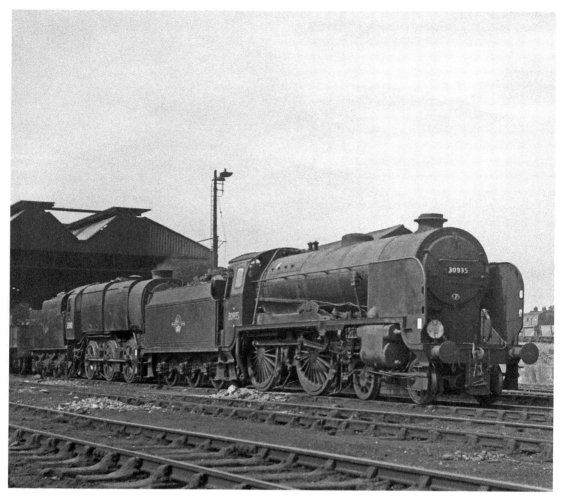

Above: Schools Class No. 30935 *Sevenoaks* at Salisbury shed, 2 September 1962.

Opposite above: Q1 Class No. 33010, Salisbury shed, 2 September 1962.

Opposite below: Merchant Navy No. 35022 *Holland America Line* at Salisbury shed, 2 September 1962.

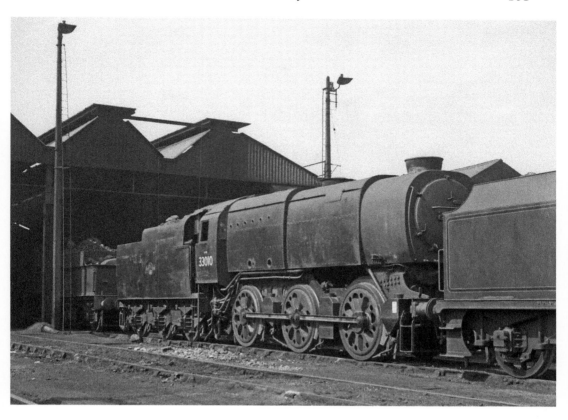

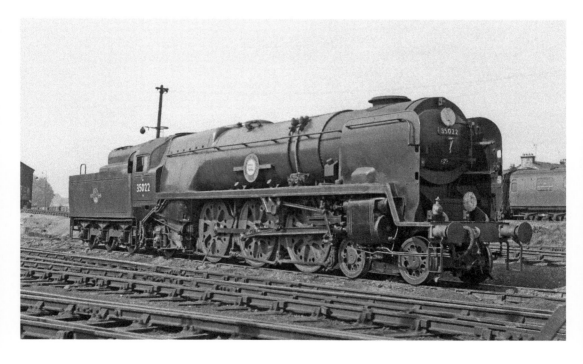

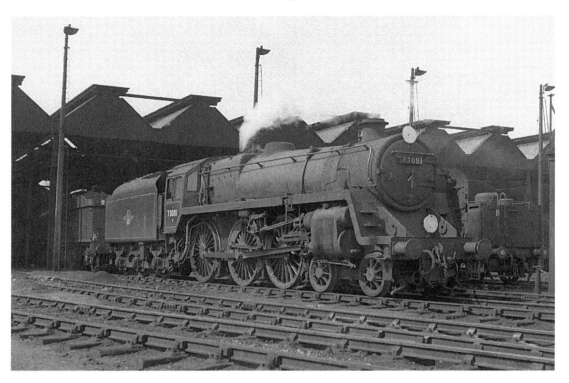

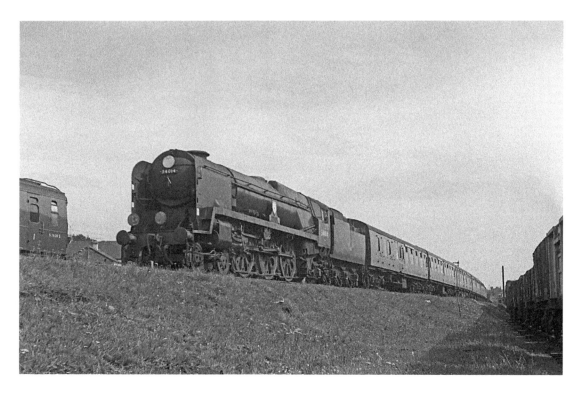

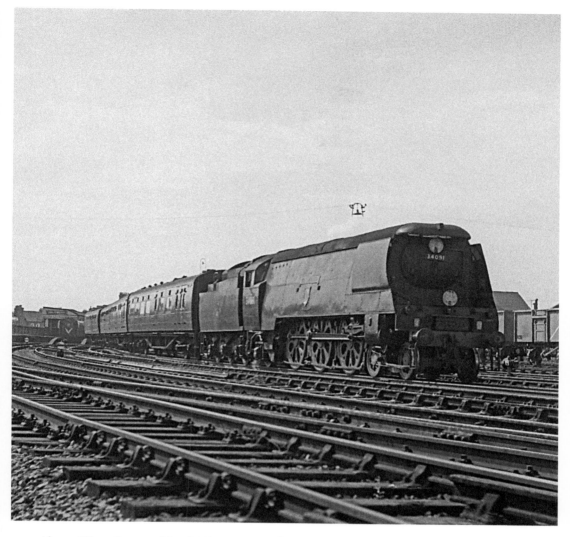

Above: West Country No. 34091 *Weymouth* leaves Salisbury with the 10.30 Ilfracombe–Waterloo service, 2 September 1962.

Opposite above: Standard 5 No. 73081 *Excalibur,* Salisbury shed, 2 September 1962.

Opposite below: Rebuilt West Country No. 34014 *Budleigh Salterton* leaves Salisbury with the 10.30 Brighton–Plymouth, 2 September 1962.

Farnborough and Templecombe

Although I have concentrated on visits to Basingstoke and Salisbury, in the summer of 1962 I also made single visits to Farnborough and Templecombe; these visits, I think, are worthy of inclusion since both locations are on the LSWR line from Waterloo and Exeter.

Farnborough

The reasons I chose to go to Farnborough on 23 June 1962 were twofold: firstly, I had never been there before; and, secondly, it was where the Waterloo–Basingstoke lines crossed over the SECR Reading–Guildford, Guildford and Redhill lines. One of the first services I saw was the 10.30 Bournemouth–Waterloo, headed by West Country Class No. 34038 *Lynton* and followed by Merchant Navy No. 35022 *New Zealand Line* with the 11.00 service from Bournemouth. The Down Bournemouth Belle was hauled by Merchant Navy No. 35012 *United States Lines*, and was followed by King Arthur Class No. 30765 *Sir Gareth* on a Down empty stock train. Several Up trains were then seen: firstly Battle of Britain Class No. 34110 *66 Squadron* with the 10.30 Seaton–Waterloo service, followed by rebuilt Battle of Britain No. 34058 *Sir Frederick Pile* on the 12.06 from Salisbury, and then Merchant Navy No. 35008 *Orient Line* with the 11.25 service from Weymouth to Waterloo.

By now I had reached the bridge over the SECR lines; there is no physical connection between the two routes. Two inter-regional services were seen: firstly, Manor Class 4-6-0 No. 7808 *Cookham Manor* on the 10.35 Birmingham–Hastings service, a regular turn for the Manors, which would work through to Redhill; and Schools Class No. 30915 *Brighton* with the 10.42 Wolverhampton–Margate service, a regular Schools turn until the final members of the class were withdrawn at the end of 1962. Back on the LSWR main line, the 13.00 service from Waterloo to the West of England was hauled by Merchant Navy No. 35006 *Peninsular & Oriental S.N. Co.* and, finally, an interesting Down movement was Maunsell S15 Class 4-6-0 No. 30833 which was running light engine shortly after being fitted with the tender from the withdrawn Schools Class No. 30908 *Westminster*.

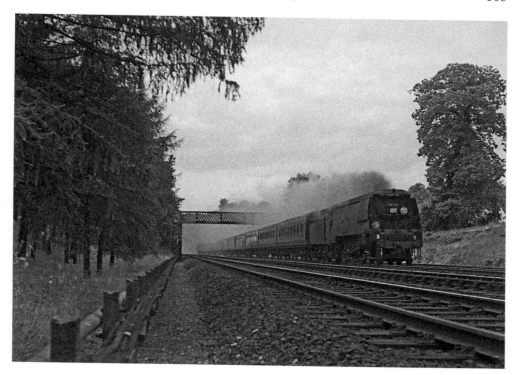

West Country No. 34038 *Lynton* near Farnborough with the 10.30 Bournemouth–Waterloo service, 23 June 1962.

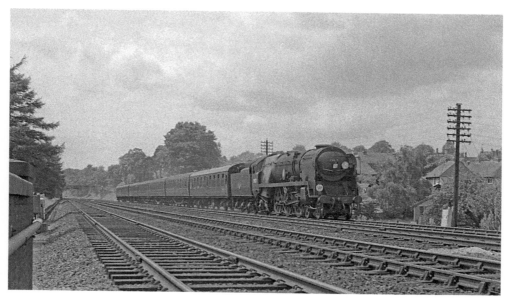

Merchant Navy No. 35021 *New Zealand Line*, near Farnborough with the 11.00 Bournemouth–Waterloo service, 23 June 1962.

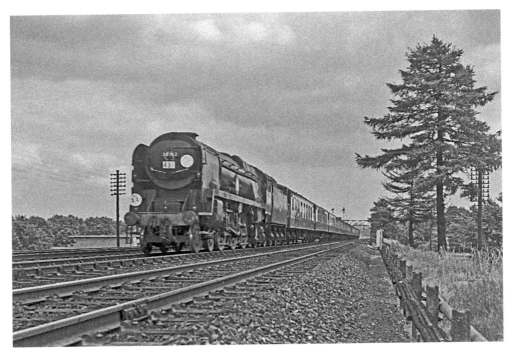

Merchant Navy No. 35012 *United States Lines* is near Farnborough on the Down Bournemouth Belle, 21 June 1962.

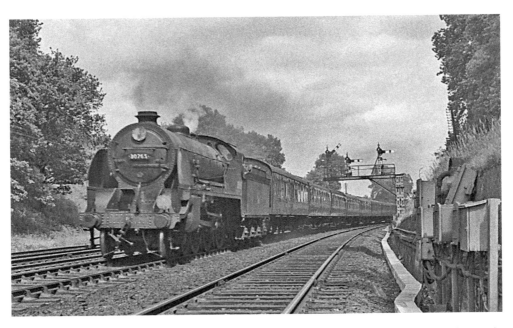

King Arthur Class No. 30765 *Sir Gareth* works a Down empty stock train near Farnborough, 21 June 1962.

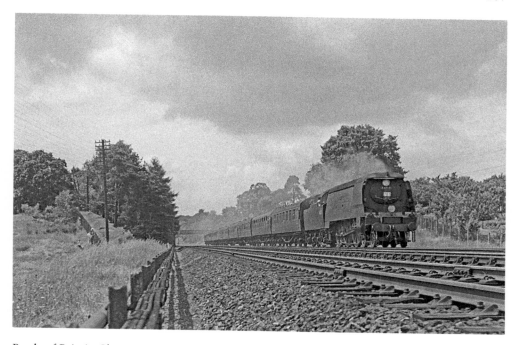

Battle of Britain Class No. 34110 *66 Squadron* is near Farnborough working the 10.30 Seaton–Waterloo service, 21 June 1962.

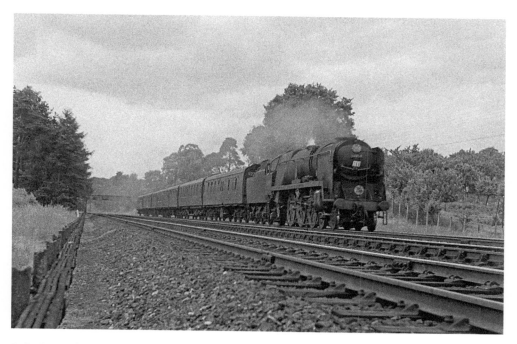

Rebuilt Battle of Britain Class No. 34058 *Sir Frederick Pile* on the 12.06 Salisbury Waterloo service near Farnborough, 21 June 1962.

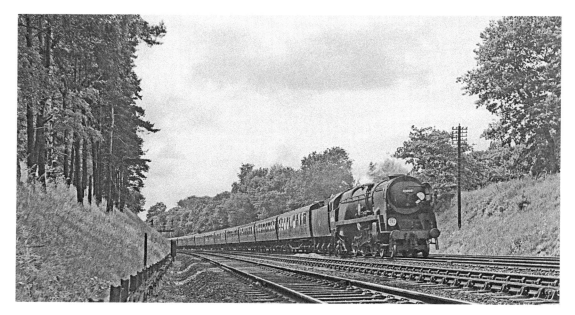

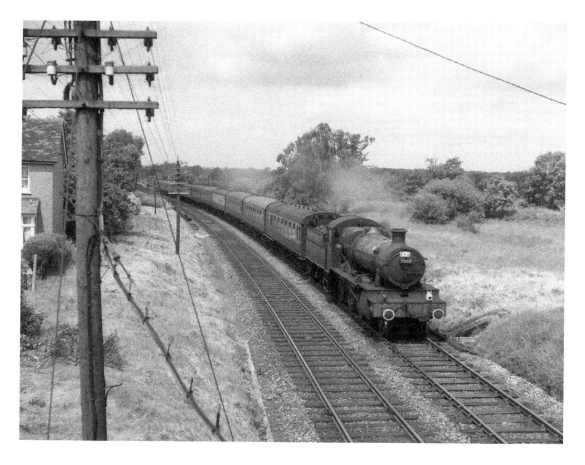

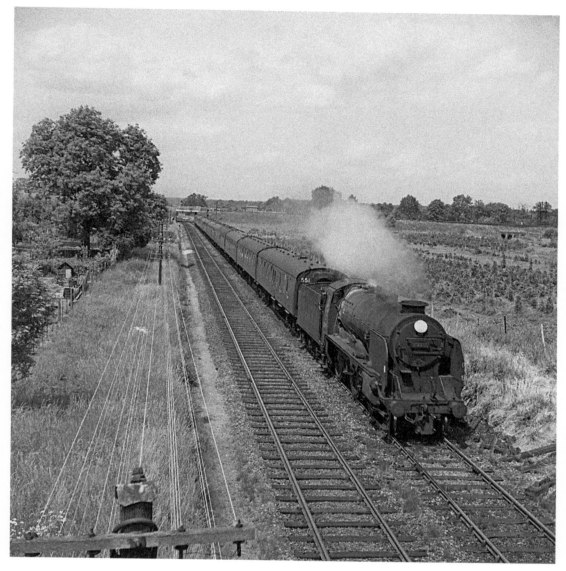

Above: Schools Class No. 30915 *Brighton* is about to pass beneath the LSWR main line with the 10.42 Wolverhampton–Hasting service on 21 June 1962.

Opposite above: Merchant Navy Class No. 35008 *Orient Line* near Farnborough with the 11.25 Weymouth–Waterloo service, 21 June 1962.

Opposite below: Manor Class No. 7808 *Cookham Manor* near Farnborough SECR with the 10.35 Birmingham–Hastings service, 21 June 1962.

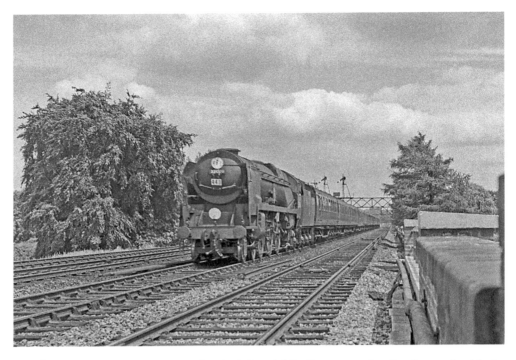

Merchant Navy No. 35006 *Peninsular & Oriental S.N. Co.* approaches Farnborough with the 13.00 Waterloo–the West of England on 21 June 1962.

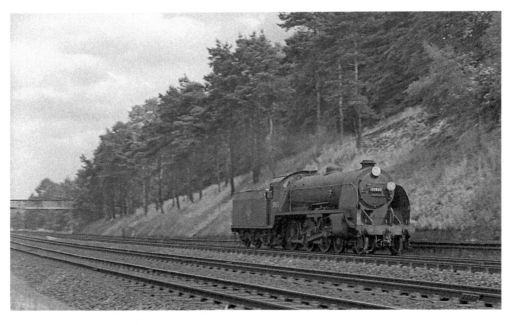

S15 No. 30833 fitted with a Schools Class tender runs light engine towards Farnborough on 21 June 1962.

Templecombe

I had passed through Templecome several times on my visits to Devon, but had never actually got off there. The station and its layout over the years is well worth a mention since it was the crossing point between the London South Western Railway and the Somerset & Dorset Joint Railway. The original single-track Salisbury & Yeovil railway station, later to be named Templecombe Upper, opened on 7 May 1860, with the line being doubled in October 1867. On 3 February 1862, the Dorset Central Railway had reached Templecombe from Burnham-on-Sea and opened its terminus station at a lower level, the station being named Templecombe Lower. By August 1863 this line had been extended beneath the S&Y as part of an extension to Bournemouth. In addition, the Dorset Central and Somerset Central railways had joined together to become the Somerset & Dorset Railway; in 1875 this became the Somerset & Dorset Joint Railway, partly owned by the LSWR. Later in 1878 the S&Y became part of the LSWR. From the onset, the two railways were linked by a curve that ran eastwards from the S&DJR to a point east of the LSWR, where a reverse line then ran parallel to the LSWR into the Upper station. This arrangement continued until March 1870 when the north to west curve was laid, which brought the S&DJR trains into an additional third platform at the LSWR station. The trains on this curve had engines at both ends to enable the S&DJR services to back out of the station to continue their onward journey. Since the majority of the S&DJR services called at the Upper station, the Lower station was closed in 1887 and replaced by a platform further south. The extension of the S&DJR to Bath in 1874 meant an increase in freight traffic and, as a result, a large goods yard was built to the north of the Upper station. The DCR had built an engine shed by the Lower station in 1863; this shed was also used by the LWSR until their own shed opened in 1867. The LSWR sheds were demolished in 1936, although locos from Yeovil Town sheds were kept there until 1950. By this time the S&DJR shed had been enlarged and was used by all locomotives up until its closure in 1966, following the closure of the S&DJR route.

The LSWR became part of the Southern Railway in 1923, although the S&DJR remained independent until its stock was incorporated in to the London Midland & Scottish Railway in 1930. The SR station was modernised in the 1930s, when a large signal box was built. In 1948 the Southern Railway became the Southern Region of British Railways; this included much of the S&DJR. However, in 1958, the S&DJR north to Templecombe became part of the Western Region, followed in 1963 by the LSWR lines west of Wilton. The S&DJR closed completely on 7 March 1966, together with the LSWR station. The LSWR line was singled in 1967 and the station demolished, save for the signal box.

In 1975 it was suggested that the station be reopened, but it was not until September 1982 that a special train was run to test the demand. The success of this and other tests resulted in its reopening in October 1983 with the use of just a single platform on the northern, signal-box side of the station. From 1983 access

to the station from the southerly car park was via an 1893 footbridge formerly in use at Buxted in East Sussex. This itself presented problems, since wheelchair users and others not able to use the footbridge needed a manned crossing. This was resolved in 2012 by extending the width of the south platform across the disused Down line so that it had a facing with the single track; although there were now two platforms, the practice was for only the doors on the south side of the multiple units to be opened.

My sole visit to Templecombe was on 4 August 1962, for which I must have caught an early train from Waterloo. I took very few photographs on the LSWR lines, the first being of S15 Class No. 30831 leaving with the 10.37 Exeter–Basingstoke service. Since the objective of the visit was to experience the S&D in action, I started to walk across to those lines and one of the first photographs I was to take there (although I must admit here and now that the sequence I am listing is probably not the true sequence of events) was of Standard 5 4-6-0 No. 73051 on the 09.30 Sheffield–Bournemouth service. To the left can be seen the line from the LSWR station going northwards. One of the locomotive types I was anxious to see were the S&D 2-8-0s designed at Derby by the Midland Railway. I was only to see just the one, which was No. 53810 on shed awaiting its next duty. The Midland was a 'small engine' company and, although one of these locos was tried out on their main line, it is surprising that they did not build some for themselves rather than perpetuating 0-6-0s and the need to double-head their heavier goods trains. The Standard 5s were very much in evidence, with No. 73048 passing through the Lower platform with the 09.03 Bristol–Bournemouth service, and No. 73054 passing the end of the loco shed and yard with the 09.30 Sheffield–Bournemouth service. Having picked up its train, No. 53810 was again seen now on the 10.42 service from Exmouth to Cleethorpes. On the curves leaving the LSWR station was rebuilt West Country No. 34046 *Braunton* with the 10.05 Bournemouth–Bradford service. By now I was on the S&DR proper; seen going under the bridge beneath the LSWR main line was Class 4F 0-6-0 No. 44558 on the 12.23 service to Bournemouth. This was one of several built to the standard Midland Railway design for the S&DR. The line south of Templecombe afforded a fine view of the LSWR route and Merchant Navy No. 35014 *Nederland Line* was in full view on the Down Atlantic Coast Express. Still in the same general area, Standard 4 4-6-0 No. 75027 approached with the 11.12 Bournemouth West–Sheffield service, followed by rebuilt West Country No. 34029 *Lundy* on the 12.20 Bournemouth–Nottingham service. Going north of the LSWR line Standard 4 4-6-0 No. 75009 doubled-headed another S&DR 4F No. 44559 on the 07.00 Cleethorpes–Exmouth service. Finally, still on the northern side GWR 2251 Class 0-6-0 No. 3215 was arriving with the 14.20 service from Highbridge. I then returned to the station to catch my return train to Waterloo in time to see West Country No. 34091 *Weymouth* passing at some speed on the 12.05 Waterloo–the West of England service, concluding an interesting day at Templecombe.

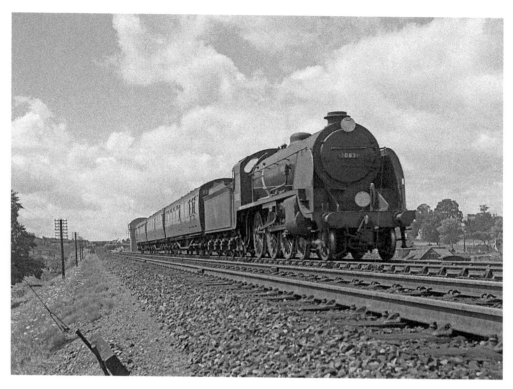

S15 No. 30831 leaves Templecombe with the 10.37 Exeter–Basingstoke service on 4 August 1962.

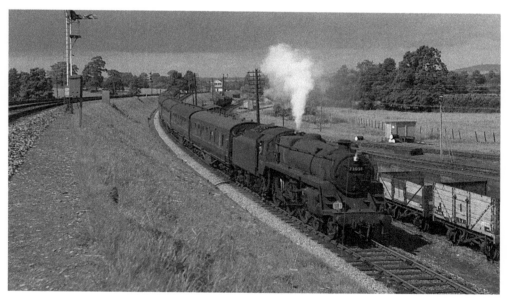

Standard 5 No. 73051 near Templecombe shed with the 09.30 Sheffield–Bournemouth service on 4 August 1962.

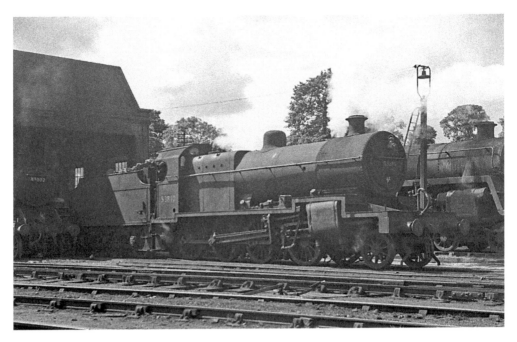

Class 7F No. 53810 on Templecombe shed, 4 August 1962.

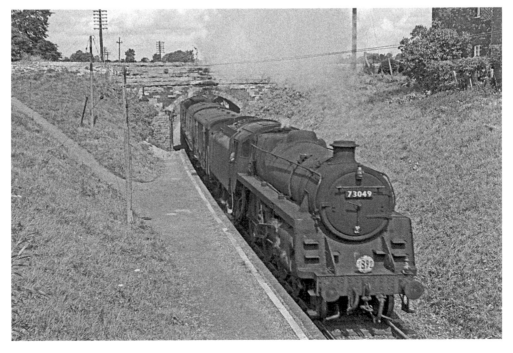

Standard 5 No. 73049 passes Templecombe Lower platform with the 09.03 Bristol–Bournemouth service, 4 August 1962.

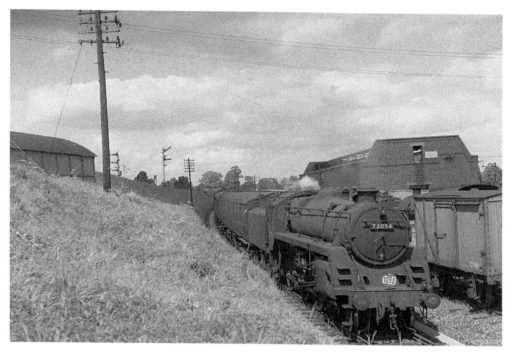

Standard 5 No. 73054 passing Templecombe shed and siding on the 09.03 Birmingham–Bournemouth service, 4 August 1962.

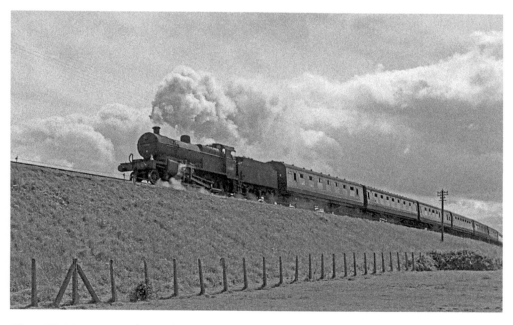

Class 7F No. 53810 drops down from Templecombe station with the 10.42 Exmouth–Cleethorpes service, 4 August 1962.

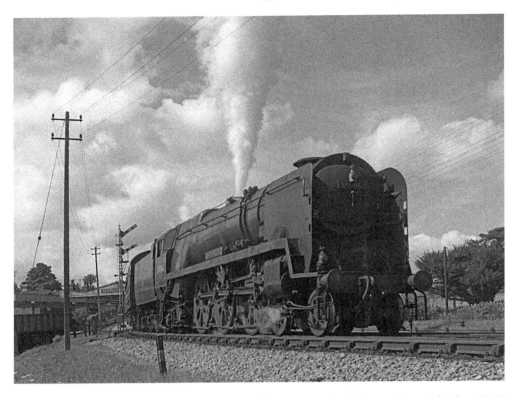

Rebuilt West Country No. 34046 *Braunton* leaves Templecombe station with the 10.05 Bournemouth–Bradford service, 4 August 1962.

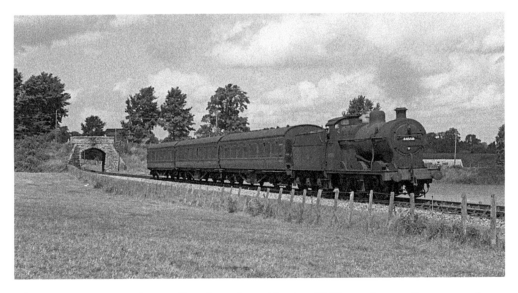

Class 4F No. 44558 leaves Templecombe with the 12.23 service to Bournemouth on 4 August 1962.

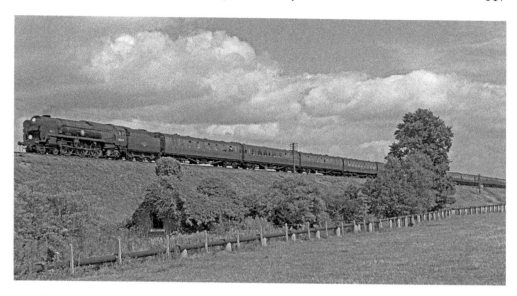

Merchant Navy No. 35014 *Nederland Line* approaches Templecombe with the Down Atlantic Coast Express, 4 August 1962.

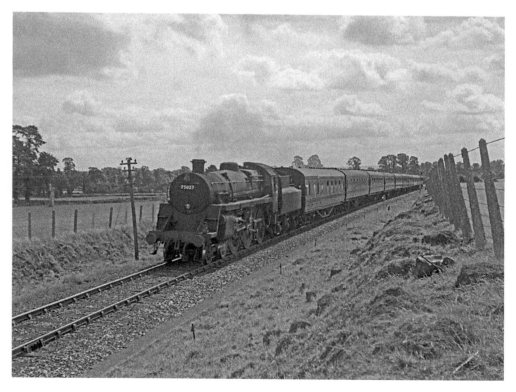

Standard 4 4-6-0 No. 75027 is near Templecombe on the 11.12 Bournemouth–Sheffield service, 4 August 1962.

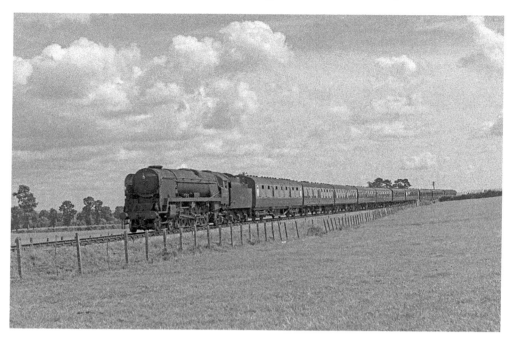

Rebuilt West Country No. 34029 *Lundy* near Templecombe with the 12.20 Bournemouth–
Nottingham service, 4 August 1962.

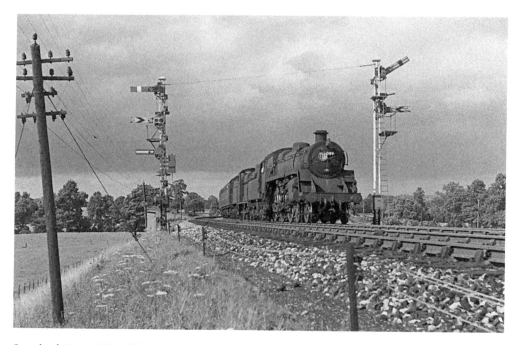

Standard 4 4-6-0 No. 75009 and Class 4F No. 44559 are about to take the line to Templecombe
station with the 07.00 Cleethorpes–Exmouth service, 4 August 1962.

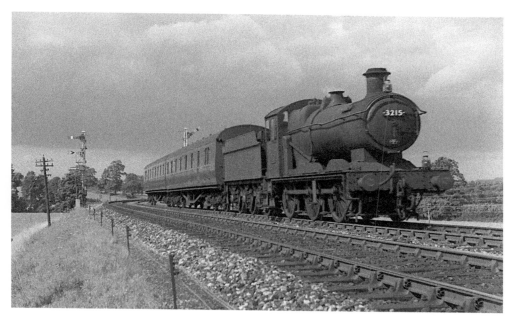

No. 3215 enters Templecombe with the 14.20 service from Highbridge, 4 August 1962.

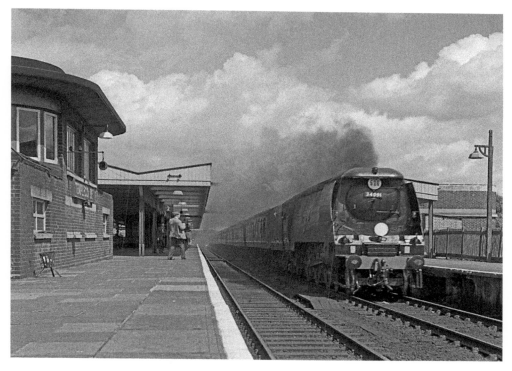

West Country No. 34091 *Weymouth* passes through Templecombe station, with the signal box on the left, heading the 12.05 Waterloo–the West of England service, 4 August 1962.

Locomotive Classes

The photographs in this book are of a number of different classes of locomotives and it seems worthwhile to give the reader some descriptive details of some of the locomotives they have just seen.

The London, Brighton & South Coast Railway had four classes of Radial 0-6-2 tank locomotives designed by Robert Billington; they were the mainstay of much of the LBSCR shorter-distance passenger and freight services. The E3s were principally used for goods and shunting and originated from a design by William Stroudly; the E4s were mixed-traffic locomotives, and examples survived until 1963; the E5s had larger driving wheels and were used primarily used for passenger work. Many E5s were in store by 1948 and were eventually replaced by the Fairburn and Standard 4 2-6-4 tanks, the last one being withdrawn in 1956. Finally, there were the E6 Class freight tanks, with several ending their days in 1963 working from Brighton and Eastleigh.

There was just the single S Class 0-6-0 saddle tank, rebuilt in 1917 from a SECR C Class 0-6-0 tender locomotive. Initially used for heavy shunting at Richborough in the First World War, it spent most of its life at the Bricklayers Arms until it was supplanted by 350-hp diesel shunters. The C Class locomotive themselves were built in large numbers and were to be seen working freight and passenger services over most of the routes in Kent and Sussex and survived up until the end of steam in those areas.

On the London & South Western Railway, the class designation was in principle that of the first works order for that class of locomotive. An example is Class M7, introduced in 1897. The first locomotives were built against order M7, followed by orders V7, E9, B10, C10, etc. In reality, there were two types of locomotive within Class M7: the original locomotives and then later locomotives built against order X14 with longer frames that gave a pronounced overhang at the front. Many of the X14 locos were later fitted for auto train operation when a compressed air cylinder was fitted beneath the overhang coupled to a Westinghouse pump attached to side of the smoke box. An example of this is shown on the earlier photograph of No. 30021 at Salisbury.

Staying with the LSWR, Robert Urie inherited a series of poorly performing four-cylinder 4-6-0s from the reign of Dougald Drummond, and there was a

LBSCR E4 Class 0-6-2 tank No. 32473 at Nine Elms on 22 September 1962, prior to being sold to the Bluebell Railway.

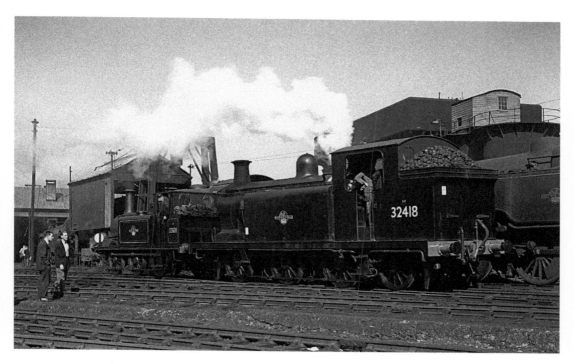

LBSCR E6 Class 0-6-2 tank No. 32418 and A1/X class No. 32636 at Brighton shed, prior to working a RCTS special train, 7 October 1962.

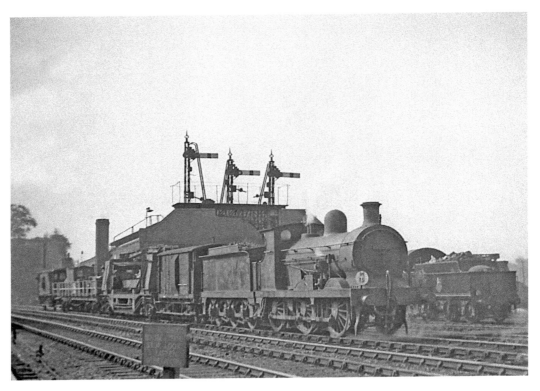

C Class 0-6-0 No. 31589 at Redhill with a track layer, 31 May 1955.

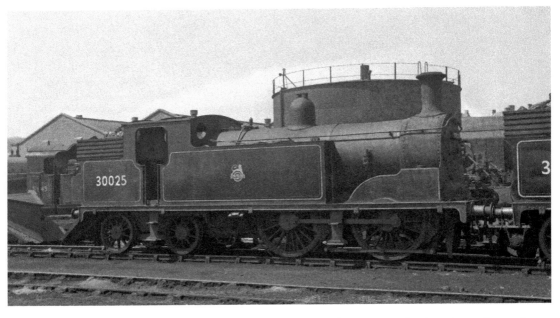

Short frame M7 Class 0-4-4 tank at Exmouth Junction. (Mick Hymans collection, date unknown)

need for replacement simple 4-6-0s to work the increasingly heavy passenger and freight services. He came up with three classes: the mixed-traffic H15s, the express N15s, and the freight S15s. All three classes had much in common – why reinvent the wheel? The N15s were later to be developed further by Maunsell as another N15 class, the King Arthurs. The first Maunsell engines were externally similar to the earlier locos, although the boiler and cylinder dimensions were different. The later Maunsell N15s had rounded cabs to fit the composite loading gauge, and also tenders with outside axle boxes. Photographs of both of the Maunsell variants are shown earlier. While both Urie and Maunsell built S15s, the two variants were visibly different. The Urie locos had the footplate raised over the cylinders, while those from Maunsell had straight footplates, rounded cabs and the same boiler as the later King Arthurs. The Urie King Arthurs and the H15s were progressively withdrawn from the mid-1950s onwards, being replaced in part by Standard Class 5 4-6-0s and Maunsell King Arthurs released after the Kent Coast electrification. The Maunsell King Arthurs had all been withdrawn by the end of 1962. The H15s were built in two series, the first with the footplate raised over the cylinders as with the Urie S15s, and later with straight running plates, plus six rebuilds of Drummond four-cylinder classes E14 and F13. A photograph of one of these, No. 30332, taken in 1956, appears earlier in this book.

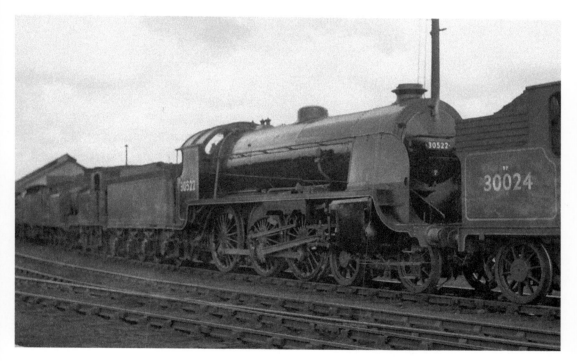

Straight-framed Urie H15 Class 4-6-0 No. 30522 at Eastleigh. (Mick Hymans collection, date unknown)

The Bulleid Pacific locomotives were probably the most advanced steam locomotives built in the UK. Unfortunately those advance features nearly brought about their downfall, as the initial Merchant Navy engines were very much overweight and also suffered many failures, mainly because of the Bulleid-designed valve gear enclosed in an oil bath. Leaking oil invariably resulted in a fire. There was no doubt that they could steam, although the coal consumption was best described as being high; yet, despite of all of their problems, they performed well, under experienced hands, in the 1948 locomotive trials. However, by the early 1950s enough was enough and serious consideration was given to withdrawing the class from service. Their saving grace was, however, the expected life of their steel fireboxes and the steaming capacity of the boilers. Consequently, in 1955 they were redesigned and rebuilt as conventional locomotives with Walschaerts valve gear. The rebuilding was a success and all were rebuilt, producing, to my mind, possibly the finest and most modern express steam locomotive on British rails. The followers of the Duchess class will not agree, but both classes were what would be best classed as 'sluggers', suited to the gradients of Shap and west of Salisbury; the LNER Pacifics, much as I like them, were really greyhounds by comparison. The smaller Bulleid Pacific, the West Country and Battle of Britain classes were prone to many of the problems experienced by their larger brother, especially oil fires, and sixty of them were rebuilt similarly to the Merchant Navies. Many of the West Country class worked west of Exeter until the Western Region took over responsibility for that part of the system, when they were all sent back to the Southern. The rebuilt engines were slightly heavier and were seldom seen west of Exeter. While they were progressively withdrawn from service, the Bulleid Pacifics worked the services for which they were designed right up to the end of steam on the Southern Region. Being the innovator he was, Bulleid devised a unique numbering system for his locomotives. Based on the Continental practice of wheel arrangement notation, the first Merchant Navy was numbered 21C1, this being the number of front and rear carrying axles; the letter 'C' denoted three driving axles, with the indication that it was first locomotive in the class. Thankfully, after 1948 the Bulleid engines were renumbered in the standard British practice.

Before becoming the Southern CME, R. E. L. Maunsell had held a similar position on the South Eastern & Chatham Railway. On joining the SECR he found there was a need for new heavy passenger and goods locomotives – a similar situation to that faced earlier by Robert Urie on the LSWR. Accordingly, he designed two classes of locomotives to meet these needs, which used a common boiler and cylinders. The goods design became the N Class 2-6-0, introduced in 1917. First World War restrictions prevented the building of further locos until 1920, although the design was selected in 1919 for 100 engines to be built at Woolwich Arsenal to enable skilled workers there to continue to be employed. Progress there was slow and, although the 100 sets were eventually produced,

the boilers being built by recognised locomotive constructors, no locos were actually completed. Eventually the Southern Railway purchased fifty of these sets, which were then erected at Ashford. Of the remaining sets, twelve went to the Midland & Great Western Railway in Ireland, followed by a further fifteen sets to the MGWR's successor, the Great Southern Railway. Of these last sets, only eight became locomotives, with the remaining parts being used as a source of spares. Six sets were purchased by the Metropolitan Railway and were erected as 2-6-4 tank locomotives for freight use, later becoming LNER Class L2. The remaining parts were eventually purchased by the Southern Railway and used as a spares source, with some parts probably utilised in the later construction of the W Class 2-6-4 tanks. The second 1917 design was the K Class 2-6-4 express tank, No. 790 *River Avon*. Further construction was undertaken after the formation of the Southern Railway; however, they had a tendency to roll at speed when working on the former SECR tracks, although this was not so evident on the LBSCR metals. Nevertheless, disaster struck on 24 August 1927 when A800 became derailed at high speed near to Sevenoaks. Thirteen lives were lost and a further forty-three people badly injured. As a result, all members of the class were withdrawn from service, pending trials. These were carried out firstly on the LNER, which were reasonably satisfactory, and then on the LSWR between Woking and Walton, wherein periods of oscillation were experienced. The conclusion of these trials was that the accident and similar problems were the result of track imperfections, and the decision was made to rebuild all of this class as 2-6-0 tender locomotives, becoming Class U. One problem with both the N and U classes in the late 1950s was the need to continually patch cracks in the front of the frames, and two types of modification were made to the worst cases. Initially new sets of frames and cylinders were constructed, but later just the front end of the frames were replaced. Although generally having a lower overall mileage and possibly thicker frames, this problem did not apply to the LBSCR K Class 2-6-0s, all of which were withdrawn en masse at the end of 1962. Following the initial success of the two-cylinder N Class, Maunsell then produced a three-cylinder version, the N1 Class, followed by a single three-cylinder passenger 2-6-4 tank, the K1 Class. Resulting from the trials following derailment at Sevenoaks, this engine was also rebuilt as a 2-6-0, Class U1, with further examples being built in 1931. The final development in the N Class family was the W Class 2-6-4 freight tanks, which utilised the side tanks from the former K and K1 classes of 2-6-4 tanks. Because of the earlier problems with large tank engines, this class was banned from working passenger services and spent much of their lives working cross-London inter-company freight services. After being replaced by diesel locomotives, some migrated to Eastleigh, where they replaced the H16 4-6-2 tanks on the ever-heavier Fawley branch trains. Others migrated further west to Exmouth Junction to replace the worn-out Z Class 0-8-0 tanks on banking duties between the two main Exeter stations. With the Western Region taking over the lines west of Salisbury and further dieselisation, the last locomotives were withdrawn by mid-1964.

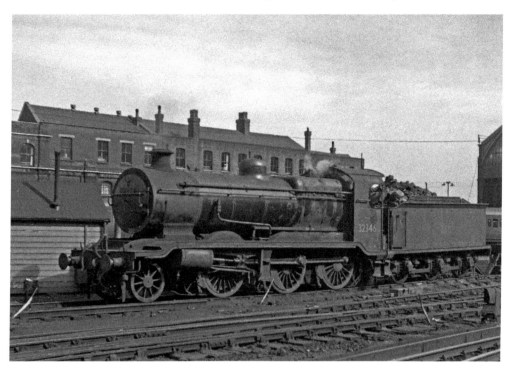

LBSCR K Class 2-6-0 No. 32346 at Brighton, 10 October 1961.

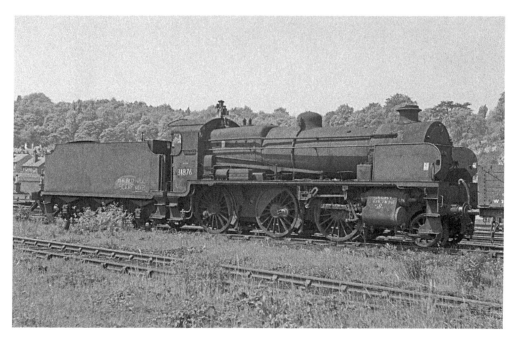

N1 Class 2-6-0 No. 31876 at Redhill waiting to be scrapped, 1 June 1963.

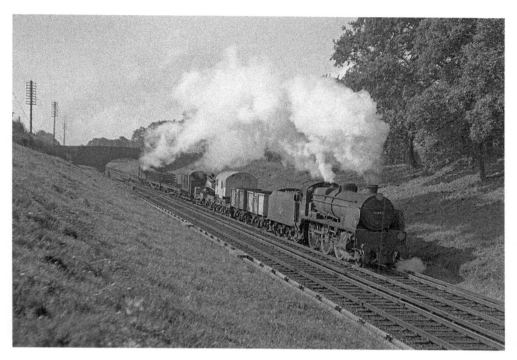

U1 Class 2-6-0 No. 31894 near Keymer Junction with a returning engineers' train to Three Bridges, 3 June 1962.

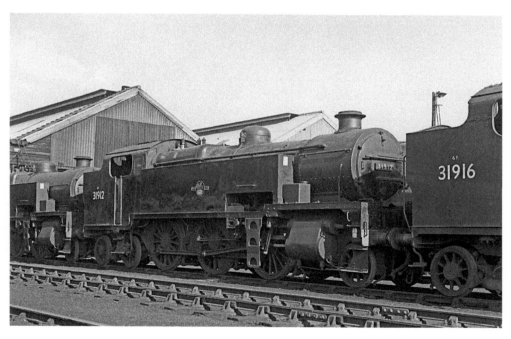

W Class 2-6-4 tank No. 31912 at Eastleigh shed 3, 27 October 1962.

Sources and Dedication

Other than where indicated, all photographs included here are my own work, most of which have never been published before. In fact, other than the original film developing, very few were ever printed, not even on contact sheets; indeed, all that happened was that a note was made of the train/service details, shutter speed, etc., which was then safely stored with the negative.

Thanks has to go to those wonderful people at Kodak and Ilford for producing the various film stocks used, and also to the developers of the Google search engine, without which most of us without access to large book and magazine collections and even larger memories would be completely lost for words.

I am indebted to John Scrase and Edwin Wilmshurst for allowing me to see their own images and for letting me to have copies when needed. The same applies to Jeffrey Gayer, John Evans and Keith Long; Brian Read has helped to resolve several queries and provided much detail regarding the operations at Salisbury after the demise of steam; finally, to Mick Hymans for letting me have access to his collection. Special thanks go to Linda Hill, who spent much of her valuable time checking the proof document for me.

This book is dedicated to all those railway workers who took me to the various locations, and never queried what I was doing wandering round the engine sheds and walking alongside the 'four foot'.

More importantly, it is also dedicated to the individuals, sadly no longer with us, who nurtured my interest in railways and railway photography: my grandfather Thomas Frederick Verrall, fireman and driver for the LBSCR and Southern Railway at New Cross; my uncle Albert Douglas Verrall, fireman and driver at Hither Green, Norwood Junction and Selhurst, whose last shift was as royal driver on the Royal Train taking HM the Queen to Epsom Races; my father Charles Thomas Verrall, porter and booking clerk who patiently sent my boxes of slides from Wivelsfield to East Croydon; the following photographers at both Redhill and Essex House who encouraged me to take up and continue photographing trains – S. C. Nash, J. J. Smith, D. C. 'The Pope' Duncan; Pat Farmer, who came on that 1955 visit to Eastleigh and Southampton Docks and was with me earlier in an observation coach on an Ian Allen special, which climbed Lickley incline while banked by 'Big Bertha'; Malcolm Burton, who introduced me to industrial railways and who was prime organiser of so many of the LCGB railtours; and finally C. G. 'Chris' Gammell, who, on the very last time we met, asked if I still had my 1960s negatives and why I had not done something about getting them printed and published. At the time I did not think it economical; however, it spurred me into action to later digitalise most of them. Without that simple suggestion, this book would never have existed.

Finally, to you, the reader, for getting this far.